PURPOSE
FOCUS
AND
PRACTICE

The Life, Lessons, and Legislation of Joyce Cohen

BY JEFFREY LEVY

PURPOSE, FOCUS, and PRACTICE

The Life, Lessons, and Legislation of Joyce Cohen

jeffreylevyauthor.com

jlevy49@comcast.net

ISBN-13: 978-0-578-88964-1

TABLE OF CONTENTS

This book is dedicated to the will-force shown by Joyce, along with her ongoing courage in meeting whatever has come her way.

INTRODUCTION

I first met Joyce Cohen in 2012 at a class at the Taoist Tai Chi Center in Portland, Oregon. Paralyzed on her left side, she used a walker to cross the floor and take part in the class. Since there were a number of members in various states of rehabilitation, I didn't pay any particular attention to her until she began to tease me. I was a new practitioner, still learning how to release the pelvis in an exercise called a "don-yu" (down spine) that looks like a squat but is stretchier and more relaxed. "Jeffrey's found his hip," she said. The comment felt good-natured and even supportive in a challenging way.

Other members told me she had been an important Oregon legislator and was still involved in advising and contacting politicians. When the Tai Chi Society was planning its yearly Chinese New Year banquet, Joyce was in charge of invitations to all the local and state politicians, from mayor to state legislators to US senators. Because of her connections, many attended the banquet. Joyce was also known for hosting a dinner as one item that could be bid on at the banquet's silent auction; it was one of the top fundraisers for the society.

After getting to know her, I offered to do a poetry reading as part of the following year's dinner. That's when our friendship bloomed. I arrived early to help Joyce prepare the meal for the ten-person party. She had several courses planned, and though she could manage with difficulty to do all the dishes, it helped to have someone who could bend and reach and chop and arrange with more facility than someone with one useful arm.

Her loft, in the Pearl District of Portland, was the top floor of an old warehouse. It was a gorgeous space with high ceilings, floor-length windows with views of the city, lovely wood floors and beams, and artwork. She had moved into the space after the stroke she'd had many years before made living in her previous house difficult. She and her former husband, Fred Hansen, had bought the property just before the area had undergone the gentrification that made it one of the prime locations in downtown Portland.

The dinner – pork roast, asparagus, salad, and wine – was a success. The poetry reading went well. I read poems by some of my favorite authors, mixed in with a few of my own works. Joyce, along with a guest who was also a poet, encouraged me to publish. It was Joyce's inspiration and support that led to my first book of poetry, *Until One Faces North*. It also cemented our relationship.

After three years, Joyce's appearance at Tai Chi diminished. She had suffered another somewhat minor stroke but serious enough that it made living independently no longer possible. By then, she had been divorced from Fred for several years. I had almost lost touch with her when I heard a rumor that she intended to take her life. The rumor turned out to be only half true, as I learned when I visited her. It was then that the idea for this book came about.

I already found Joyce remarkable in the strength and determination she showed in pursuing Tai Chi, independent living, and travel even though she was paralyzed. As her history unfolded with the exploration of writing this book, her life seemed even more surprising and inspiring. Her journey – from isolated farm girl to medical tech in pioneering open-heart surgery; from medical researcher to witness of the Watts Riots and Black Panther movement; from serving as one of the most important Oregon legislators for twenty years to being a world traveler and investigator of spiritual and energy movement – was as curious to her, in the telling, as it was to me. It was, as this book intends to highlight, a life of purpose, focus, and practice.

Over the course of researching this book, I have had the op-

portunity to meet many individuals whose lives have been touched by Joyce. Naturally, this doesn't include the hundreds of thousands or more who have been affected by her legislative work. I did not meet anyone who didn't speak with admiration and even awe of her will-power. Repeatedly, I heard, "Joyce is the strongest person I have ever met."

Sitting with Joyce on a day when her eyes were bothering her and she was feeling muddled with a palpable sense of decline, I saw her briefly tear up. What she can still do becomes more and more limited, yet she perks up with the spirit and humor that has defined her life. "I can do my exercises," she says. "I can appreciate the birds chirping at the feeder. I've had a good life, and it is still going on."

Talking with Joyce, even when she feels diminished in acuity, is to field a nonstop barrage of anecdotes, connections, memories, and insights. Although conversations may not be obviously guided by or-ganized focus, methodical practice, or predetermined purpose, they always contain a thread of each.

For Joyce, to have purpose means having a vision of an alter-nate future and a commitment to something greater than the self; it means to have curiosity about the world in which we live no mat-ter how mundane (or exotic); it means making the time and space to gather and to think; and it means daring to act on the uncertain. Though beset by brain and vascular anomalies since childhood and the confusions and compromises of medicine, Joyce practices purpose and focus every day.

On the most basic level, it takes purpose, focus, and practice to get out of bed and attend to bodily function. With her disability, she has to concentrate on moving her arm and leg to roll over and sit up, to get into her wheelchair, and to go to the bathroom. Every day she exhibits determination to go outside and practice her Tai Chi and Qigong exercises – the repetitive stretching and strengthening that counteract the limitation in muscle tone and circulation in her body.

She finds it vital to interact with the maples, cedars, humming-

birds, and rabbits that appear in the backyard and neighboring park of her living facility. Each plant and animal deserve attention, and it is part of her practice to engage with the natural world assiduously.

Purpose, focus, and practice support each other. Practice without purpose is deadening routine; purpose without focus is dreamy talk; focus without practice is prone to error and misjudgment. The more effort put into making visions real, the more the ideal can live. And the more commitment to a high purpose, the easier and more necessary a real practice becomes. For Joyce, the elements of purpose, focus, and practice reinforce each other to make an effective and meaningful life.

Although this book is in many ways a biography, Joyce was insistent from the start that our work together be about lessons learned and how they might help others, especially young women, working in the public sector. To that effect, this book is organized into three parts, each of which highlight thematic lessons from her life. Part one focuses on her childhood and young adult years in South Dakota and beyond; part two dives into her years in the Oregon state legislature and the lessons she learned along the way; and part three features her later years of adaptation and acceptance that encompass the loss of physical abilities and the heightening of her energetic and spiritual awareness. Woven throughout the book are the principles of purpose, focus, and practice that represent the whole of her life. May you gain as much from reading about her life as I have by knowing her.

PART I
EXPLORATION AND
DISCOVERY

PART 1
EXPLORATION AND
DISCOVERY

CHAPTER 1
Reframing Purpose

Imagine clear, fiery eyes shining out of a face topped with a mop of white hair; the left side of the face is partially immobile, while a torrent of memories, insights, and decisions pour out of the vibrant aging woman before you. The words are in restless contrast to the paralyzed features of the woman in a wheelchair, who was born on the Midwestern plains in 1937 as the Depression wore down. Each person is a story, and the story of Joyce Cohen is, in her own words, one of purpose, focus, and practice.

The assisted-living house is on a suburban but loosely packed road outside of Portland, Oregon. It houses four or five residents, most of whom are partially withdrawn in their decline, watching endless television or dozing in their chairs. Joyce's room is small with a handicap-accessible bathroom off to one side. A large window looks onto a patio where Joyce does her exercises. Beside her bed sits a computer and an adjacent desk. The only other furniture is one upright chair and a small display table.

On the wall hangs a display of bow ties she wore in the Oregon Senate. Next to the computer is a boxing glove – a reminder of a safety regulation she helped to enact. In desk drawers are papers with headline after headline about her work with six governors and other main political actors for thirty years in Salem.

Under the bed is a stack of books filled with dog-eared pages, slashes of highlight pen, and scribbled notes: Doris Kearns Goodwin's *Leadership in Turbulent Times* about Lincoln, the Roosevelts, and Lyndon B. Johnson; *Opening the Dragon Gate* about the forming of a Tai Chi master; *Lab Girl*, about the development of a young scientist. *New Yorker* magazines abound, along with books and articles about trees, sleep cycles, mediation, and interpersonal communication. The items in her room suggest a mind very much alive. Still, Joyce came here to die.

Joyce's decision to terminate her life was brought about following a second minor stroke. During care, a blood pressure cuff was left on her good arm overnight, causing more damage and ending the possibility of living independently. With that, her sense of purpose diminished. Incessant pain, loneliness, crippling disability, and even perhaps sacrifice – the idea of moving on without regret – fueled her decision. It was not a new thought or an epiphany. All her life she had known and not been mystified by endings. It is a natural consequence when purpose, focus, and practice practically cease.

Joyce's whole history had taught her both decisiveness and familiarity with death: envision a purpose, focus on the means, and prepare for the result. She might well have quoted William Butler Yeats's 1916 poem entitled "A Man Young and Old, Section XI From Oedipus at Colonus":

Endure what life God gives and ask no longer span;
Cease to remember the delights of youth, travel-wearied aged man;
Delight becomes death-longing if all longing else be vain.
Never to have lived is best, ancient writers say;
Never to have drawn the breath of life, never to have looked into the eye of day;
The second best's a gay goodnight and quickly turn away.

Yeats imagined the exiled, weary Oedipus – the ruler, master politician, ruthless truth-seeker, self-blinded, paradoxically beloved of the gods – at last finding solace in acceptance of the inevitable.

Joyce's decision, which came after months, and even years, of developing this kind of acceptance was met with opposition not only from those who knew or worked with her but from the medical establishment. Confrontation with the latter was not new. Joyce had had a long history of challenging medical management and following her own advice. The fact that doctors wanted her to take medication that she felt diminished her agency was a sore spot. She refused; her caretakers insisted.

Very well. Enough would be enough. Despite the standard of care for most patients in these circumstances being the prolonging of life at all costs, Joyce would take care of her life herself. Without a larger purpose, the potential loss of focus, and no ability to practice, there was no life.

In Oregon, physician-assisted suicide has clear restrictions. Ironically, Joyce had been involved in making this pioneering legislation for the state. For a doctor to participate required a considerable set of safeguards. Some of the conditions Joyce did not meet, and Joyce was well aware of this.

She also was aware of other ways to commit suicide "acceptably." Voluntary stopping eating and drinking (VSED) exists in legal limbo in several states; in Oregon, it is considered an acceptable way to take control of one's own life, with medical intervention only used to alleviate some of the discomfort of dehydration. (State-by-state information is available at the Patient Rights Council.) All this takes is enormous will and determination. Joyce was prepared.

What kept her from going through with her initiative will be explained later. But in a nutshell, she reframed her purposes; she continued to consult with legislators, offering advice and insight into current negotiations. She met with old friends and collaborated in a variety of historical reminiscences of her dealings in Salem. She entertained fam-

ily and friends and encouraged her grandchildren to actively pursue scientific studies addressing climate change and the environment. She decided to help frame a book (which you are reading now) that could offer advice and insight on a meaningful life, aimed especially but not exclusively to young women who choose to enter politics.

Viktor Frankl, in reflecting on the unimaginable horrors of his time in a Nazi death camp, wrote in *Man's Search for Meaning*: "Everything can be taken from a man but one thing: the last of the human freedoms – to choose one's attitude in any given set of circumstances." Joyce has reframed purpose all her life and, in doing so, found meaning in discovering purpose even in decline. It is the freedom of reflection and its use for others.

Her long life seems improbable to her. It began, after all, in the era of the Great Depression. Let's go back...

CHAPTER 2
Self-reliance

It was a time of difficulty and even desperation for so many. Farmers who had not been driven off their land by the catastrophe of the Dust Bowl or repossession of their property by the bank faced intermittent loss of income from overproduction and plunging grain prices. The rural Midwest did not have much governmental support, and along with the usual vagaries of weather and price lability, farm life fostered strength and endurance for survival.

Joyce's paternal grandfather, Vaclav Petik, immigrated to the United States in 1904 from Bohemia (now Czech Republic). With family, he claimed a homestead in the far northwestern part of South Dakota in the 1920s. Her mother's family, the Sampsons, also homesteaded in western Minnesota and the Dakotas. The Indian wars of the 1880s were still a recent memory, although the buffalo were gone and the Lakota confined to their reservation. The gold rush in the Black Hills was over, and Gutzon Borglum was just beginning his mad quest to turn Mount Rushmore into a national monument for promoting tourism.

The Petiks, Sampsons, and Holmquists (family of her maternal grandmother) were farmers and ranchers. If you were dedicated to hard and ongoing work, you could acquire a piece of land large enough to ranch or farm. There were torrid summers and frozen winters and the eternal boom/bust cycle of the American farmer. But there

was a living. The families bought land tracts close to each other.

Vaclav had three sons and three daughters. Joseph, the youngest, was born in 1906. He grew up knowing the farming life his father had begun, with three horses and a walking plow. The ground was stony, and survival was difficult. Joseph's mother died from the flu in the winter of 1918. She couldn't be buried until the spring because of the frozen ground. It took three days for Joseph and his brothers to dig the grave – a grave left unmarked because of the number of flu victims in the area and the difficulty of marking the site. In 1934, Joseph married Evelyn Sampson, a schoolteacher from Minnesota who taught at a variety of one-room schoolhouses around the Dakotas. Hers was a world arduous as her new husband's. She told him a neighbor was knocked unconscious while transporting a load of lumber in a wagon. When the horses reared, the lumber hit the man in the head, even shearing off one of his ears. All night, coyotes circled the man. He was found barely alive early the next morning.

It was the heart of the Depression, but Joseph and Evelyn were able to get by. Three years after their wedding, they had their first child. Joyce was born on March 27, 1937. Joyce says their first lodging was a chicken coop loosely converted into a home while a permanent house was built. (Photographs from around that time show a simple house near completion.) They lived a spartan, almost frontier life, above subsistence but tenuous and demanding.

The farm started as 140 acres but grew to several thousand, with pasture and ranch land. The land is still in the family, though most of it is rented out to other farmers. In addition to a house and barn, there was the necessary vegetable garden and a well. A small creek ran through one edge of a pasture where one could paddle and even do a little fishing. "Life on the ranch was all about survival," Joyce says. "We had to work hard. It was a constant struggle to try to make a living out of the ranch." Survival was about more than individual human subsistence. Care of the livestock, the plantings, and for the health of the water, soil, feed, and interaction of these elements was

part of survival. What is now called environmentalism was at the core of daily and seasonal farm life.

Initially, there was no indoor plumbing or electricity. One of Joyce's chores was using a hand pump to get water from a well. There was a furnace that needed to be fed with the coal that was delivered to the house. In winter, when the day was over and dinner finished, there might be a little reading before bed. Later, in the 1940s, there was a radio that the family listened to on Saturday and Sunday. The family did not do a lot of socializing or attending church. Trips into town were made only when necessary for groceries or gas. Clothing was made or mail-ordered from Sears.

It was on this farm that the lessons of purpose, focus, and practice grew. Here too, interestingly, was the genesis of negotiating and working with who or what was at hand that later became part of Joyce's political life.

Purpose was naturally built into the requirements of subsistence but went beyond mere eking out a living. There was a community of family, relatives, and workers to attend to the needs of animals. There was also the demand of self-reliance both for each individual and for the community. Though not a devoutly religious family, they shared an agreement about the larger purpose of sustaining the environment and their people (though this did not much extend to impoverished Native Americans). While making use of the land and livestock for human purposes, they respected and conserved soil and water so that it could be passed on to children and grandchildren.

Even more than purpose, the teachings of focus and practice were demonstrated by daily work, long hours, and unending chores governed by weekly, monthly, or yearly cycles. The work was done all alone, and work done poorly had to be redone: a fence sloppily put up would need rebuilding. Items forgotten had consequences: a cow unmilked suffered. Mistakes had to be understood and mended, just as bread over-risen collapsed to a dense, unpleasant loaf. One applied oneself and shaped their personal drives and desires to work.

At the same time, there was little explicit direction. You had to figure out how to see what needed doing, how to achieve the doing, how to accommodate your abilities to the matter at hand, and how to master your inner world to meet those needs.

Joyce remembers beginning to help as early as age three or four. She would go out into the grain fields and help bind up shocks with twine. She remembers following along and reaching with little arms around the bundle to tie it. One learns work early in a farm life.

Of course, there were also chores in and around the house: cleaning, fetching water, collecting eggs, weeding the garden, mending, and a thousand other jobs that a farm child grows into. These things were learned almost by osmosis, Joyce says. Her parents rarely instructed her and, in fact, rarely spoke at all except to say what needed doing. Children imitated adults or figured it out themselves. She remembers only one time that she was particularly instructed. A calf had a hurt foot, and her mother told her how to clean it and bind it up. That helped in one instance, but the next time the circumstances and needs would be different. She learned to apply herself to the moment. Independence and observation were the essentials. In later life, this initiative served her well in learning the basics of legislating; she had to figure out what needed doing and how to get it done.

As she grew older, the chores became more various and demanding. She had to take the pail to the barn, clean the cow's teats, and milk the cow, being careful not to spill the pail or get stepped on by the cow. For refrigeration, there was ice brought in and put in an ice box. Horses needed feeding, grooming, and the stables mucked out. Naturally, Joyce learned to ride – saddling and unsaddling the horses, taking care of the tack. Chickens had to be fed and kept safely; their eggs had to be gathered. In time, the chickens would have to be butchered and plucked for food and feathers. There were fence posts to set, often by digging the holes manually, and stretching wire fencing.

The garden, being the source of much of their produce, was especially important. In spring the soil had to be turned over and fer-

tilized, then planted. Later, there was weeding and hoeing under the sun. Root plants had to be dug up. Pickling and canning were related skills that took many hours. These early lessons became central to Joyce's life.

When Joyce was around the age of nine, her father's heart condition made it difficult for him to shovel grain. Though small and lacking the strength of an adult, on her own initiative, Joyce spent aching hours helping her father, digging into the truck-wagons of grain and throwing it into the silos. The sun beat down, her shoulders burned and complained, but the shoveling went on until the job was done.

Life was not all work. There were dogs to play with and insects, snakes, and birds to observe. Climbing down to the creek, there might be berries to pick or frogs, fireflies, grasshoppers, and crawdads to catch. There were beavers to observe and occasional fish to catch. In nearby Lemmon, there was a petrified-wood park and museum. As a young teen, Joyce was fascinated by plant life that had been transformed into solid rock and experienced closeness with what had once been alive as anything now living on the ranch. When touching fossils, she vibrated with their frozen life.

Daily contact with the elements builds a strong immune system. For Joyce, the organisms in the soil, water, and wind became the basis of lifelong strength. She and her siblings learned to adapt and even heal themselves. There was little room for self-pity on the farm, except in extreme cases. Joyce never had colds or the flu, as far as she recalls. To this day, her children comment that they have never seen her sick.

In her childhood, going to the doctor was not a rarity; it never occurred. The only medical professional in the area lived in town and everyone in the family said "he was a notorious drunk." So, any medical treatment usually happened at home. There was no ambulance service, and the hospital was far away. The Petik family relied on themselves for care.

There was little coddling from her parents. Children did their

work without praise or recognition. Mistakes or sloppiness were scorned but rarely punished. There was not much talk except related to work and not much warmth around the dinner table. Her mother was a cold, stern woman. "The culture in our family and a lot of families was Swedish. My parents were distant, not openly affectionate. That was just how it was. You didn't talk about personal feelings. We didn't really talk much at all," Joyce remembers.

It wasn't until later that Joyce discovered different family dynamics. Looking back, she grew to understand that this lack of interchange felt like a loss of love; as such, her father's death in 1965 and her mother's in 2004 were not emotionally charged moments for her. Furthermore, growing up on the farm, she had become intimate with death via the passing of animals; to her, death was a normal part of life.

Although her upbringing was emotionally spartan, Joyce does not regret her childhood as much as wonder at it. In many ways, life on the farm was free. Out in the sunshine, in all kinds of weather, working in colloquy with critters and family, visiting the creek, she experienced the fresh smells of the field and yard, the songs of the birds, and the rhythms of the day and the season. Nature was her family and what gave her a sense of community, together with her relationship with her siblings.

A key responsibility for Joyce was the care of her younger siblings: with the arrival of Bob, when she was four; Judy, when she was seven; and Joan, when she was nine. She was a second mother and a schoolteacher to them. Changing diapers, feeding, reading to them, overseeing their chores, and playing with them were added to her own farm and schoolwork.

Joyce was a natural caretaker. At an early age, she learned to care for animals, both those they raised and those that lived wild on their property. Understanding the needs of fellow creatures built compassion and engendered a desire to live beyond herself. In caring, one begins to focus on the greater needs and to see the forest as well as

the trees.

Joyce was a bright and able child. She was a quick learner. Joyce's mother was a schoolteacher, and while Joyce was not directly taught by her mother, there was an unspoken understanding that school was important. Learning to read and write, do arithmetic, and comprehend the basics of history formed a critical foundation to her education. Good grades were expected. In the one-room schoolhouse, she had a young teacher she liked and was friends with both boys and girls. She was always the only child in her grade.

"I walked or rode my bike over a mile to the one-room schoolhouse. It was in the country, not the town. The school had only seven grades," she shares. In that environment, the older children also guided the younger ones. When Joyce reached fourteen, there was no high school near enough to the farm that she could commute to; the closest high school was in Lemmon (boasting a population of three thousand), almost sixty miles away.

But not attending school was not an option. Her parents found her a boardinghouse near the school, although they didn't really know the family – nor did Joyce, ever: "I only saw these people on my way in or out of the house. The family were strangers when I moved in and strangers when I moved out. Sometimes people thought it was an odd way for a young girl to live. But that is what I knew." She lived in the attic and cooked her own meals on a hot plate. Other than school, she was all alone. She rarely got to the ranch on weekends. It was not until summer that she could move back home for the work that needed her.

Joyce learned more independence and self-reliance during her time away in high school. Her studies were excellent. Her essays were written in beautiful handwriting and received high grades. Teachers recognized a bright, eager student. One essay from the time is titled "Why Not Break It."

How do you go about the business of breaking a date? Let me tell you of an incident that once happened to me. I did not want to

keep a date that I had accepted some time ago...

I asked my best girl-friend for her advice and just as she was telling me to keep the date, a group of unconcerned girls walked by and soon they were all telling me exactly what they would do in a situation like that. Why, there was nothing to it—just tell him you had to babysit and then accept another date.

Finally, I decided I could not bring myself to do such a thing so I waited patiently for the dreaded night to come. In the meanwhile, the whole school had taken it upon themselves to offer me advice... I ended up going on the date and found myself having loads of fun. All my worries had been for nothing and I thought of the fun I would have missed if I had told the boy of the terrible attack of asthma that I had planned to have that night.

The essay shows several qualities that later marked her political and personal lives. Not atypical of teenage girls, the personal question became a social one. However, after consulting, Joyce made up her own mind and went against the prevailing advice. An inner moral commitment to honesty overrode the convenience of telling a lie. Then, she drew a lesson in discovering not only that her misgivings were based on fear but that overcoming them led to a positive new experience.

The social life of teenagers, especially in the postwar years when teenage culture was about to explode with the development of rock and roll, car culture, drive-ins, interstate highways, and Hollywood's discovery of a baby-booming market, was important to Joyce, but she was too grounded to become wild. She joined a group of girls, attended dances and football games, and went on dates. Her scrapbooks are stuffed with school events, invitations, thank-you cards, and many, many notes from her peers. Another one of her essays was about which boy to get involved with – not necessarily the most popular one. By sixteen she had a boyfriend, and being a farm girl, when she ex-

plored intercourse: it was at noon, she noted, and in a trailer house. It was pleasurable and exciting, but not something to be wholly distracted by.

In her later teenage years, the drive to reach beyond immediate boundaries was strong. What was the world calling her to experience or to achieve? Joyce remembers, "I could hardly wait to graduate from high school and get out of South Dakota. I dreamt of becoming a veterinarian or a doctor and I wanted to get started." However, college and medical school were expensive, well out of the reach of the family's resources.

Above all, she didn't want to be trapped in the narrow confines of a farm life as a young mother. Though she could hardly conceive what it would mean, she thought of herself as a healer – destined to help others. "Most of all, I wanted to see more of the world." Yet, she knew she couldn't rely financially on her family.

Purpose, focus, and practice by then were habits. Now, how to use them?

CHAPTER 3
Travel and Research

What lay out there beyond the farm and beyond Lemmon? Joyce, freshly out of high school, wondered. It didn't take long for her to make up her mind. "In 1953, right after I graduated, I took the train out of Lemmon. I never talked it over with my parents. I just told them I was leaving. I made my own choices."

She continues, "I bought a ticket to Minneapolis because that was as far as I could go on the money I had saved." Minneapolis was a big city, a world apart from her family, the rural life, and everything she knew. "Right away I took a job at a soda fountain, found a roommate and an apartment." She was only seventeen, and the future lay enticingly ahead.

As soon as she could, she enrolled at the Minneapolis College of Medical Technology. The school was a cross between a technical training program and what would now be called a community college. The study at the college was serious and challenging. The basics of chemical and biological laboratory work were taught rigorously. All the students — mostly female — were uniformly dressed in lab coats with their hair pulled back into neat buns. They learned how to draw blood, how to separate it in centrifuges, and how to precipitate the sera. Slides of bacteria were examined along with tissue samples that had been sliced and stained by the students. Students were shown how to take

X-rays and how to read them. The machinery of the time was simple compared with the computer-enhanced items of today, but it required knowing the basic engineering of the body and the equipment used to explore it.

Already prepared by her farm work, she brought a physical skill to her work. Dissecting, bloodwork, and lab procedures proved to be no challenge for Joyce. She reveled in the details and precision of scientific work. Dedication to following through – work until work is done – served her well, along with her curiosity and reading.

On top of her schoolwork were the jobs that kept her afloat and the normal chores of cooking, laundry, and cleaning. Her family lent a tiny contribution, but principally she was on her own. She didn't have a large social life but would catch the occasional movie with a classmate. In 1956, *Oklahoma!*, *Rebel Without a Cause*, *Lady and the Tramp*, and *The Seven Year Itch* were popular.

She relates, "After two years, one of my teachers recommended me for a job at the University of Minnesota Medical School." This was a significant opportunity that was later mirrored by her pioneering work on DNA and radiation in the blood. Because of her dedication, she was asked to join the support team for Dr. Walton Lillehei, a professor in the department of surgery at the University of Minnesota. Eight years earlier, Lillehei had been part of a team that had begun exploring heart surgery by opening the chest wall. He was a major participant in the world's first successful open-heart operation, using hypothermia, performed at the University of Minnesota on September 2, 1952.

Lillehei went on to head the team that, on March 26, 1954, performed the world's first open-heart operation using cross-circulation. This involved hooking up a father to take over the pumping and oxygenating processes for his thirteen-month-old son. Joyce was in charge of monitoring the oxygen levels of the recirculated blood. It was a historic and successful operation (although within two weeks, pneumonia claimed the child). In the following year, more than forty-two open-heart surgeries were performed for a variety of problems and

with a survival rate of about 75 percent.

Work with laboratory animals supported the studies into open-heart surgery. Because of her farm background and feelings toward animals, Joyce was especially good at taking care of the dogs used in the experimentation. Soothing their fears, prepping them for surgery, and taking care of them afterward came naturally to her. This was a major step into the wider world, using her background and schooling to assist in an enormous medical advance. She found the work engaging and serving of a larger purpose. Science worked through discovery and experimentation, but it wasn't magic; her work demystified medical technology. She understood that medicine was governed by assumptions and that doctors, doing their best, are guided by current knowledge – which may or may not be what works best for the individual.

After several years in Minneapolis, Joyce's curiosity was still great. "I loved the work at the med school, but I wanted to see more of the world." She imagined what lay beyond the South Dakota farm and Minneapolis laboratory. There was so much more!

When a nurse at the hospital, who was from Florida, suggested that Joyce join her down South, she thought, "Why not?" She had never seen a palm tree, been bitten by a no-see-um, picked an orange from a tree, or swum in warm ocean waters. Now that she had finished her degree and worked professionally in a laboratory, it was time to explore. She quit her job and drove with the friend to Florida. She even learned to play golf, which she might have had better luck at than she did at work. "I found a job as a waitress at a resort hotel, but I wasn't a good waitress. I never got my toast served in time, and I was a bit of an upstart." She found the other women too servile and the male managers full of themselves. Serving in a restaurant wasn't as meaningful as laboratory work or even shoveling grain. It called for a level of subservient precision that seemed trivial compared to what she had been used to. Her comments weren't welcome.

Consequently, she did not stay in Florida long. A new adventure beckoned: a short trip to Cuba. It was more exotic, beckoning, and

mysterious than Minneapolis had been. She decided to go alone, just as she had gone alone to Minneapolis. She would figure out where to stay and how to get around. This was prerevolutionary Cuba led by the dictator Fulgencio Batista. It was the Cuba of American gangsters and the United Fruit Company and, up in the hills, a small band of farmers who were being coalesced into an army by a young law student named Fidel Castro.

Cuba in the 1950s, before the Castro revolution, was a scene of wealth and squalor. Shanty shacks and beggars and hungry children with pleading eyes filled the streets where mafioso, commandantes, and rich and bloated sugar kings passed them by. The corrupt Batista government, fueled by both internal and American elites, presided over a government that served no purpose other than enriching the wealthy.

Batista came to power in the 1930s. He helped stage a coup and remained one of the main powers behind whatever government figurehead was in place. Though he rose in power through alliances with Cuban communists, it became fashionable after World War II to be staunchly anti-communist. In this way, he enlisted the complete support of the US government that helped him in a coup to overthrow the elected Cuban president. In the 1950s, American sugar corporations and mining interests controlled most of the Cuban agricultural economy, greasing Batista's wealth and power with payoffs. The notorious gangsters Meyer Lansky and Lucky Luciano befriended Batista and set up major gambling and casino concerns that bribed and colluded with the strongman.

Joyce had never seen poverty like what she witnessed in Cuba. Her life on the farm hadn't been easy; many people lived in some degree of difficulty, and the Lakota were poor. But Cuba was different. The division between the wealthy and the poor was appalling. Compounds topped with razor wire and cut glass were patrolled by guards while whole neighborhoods were blighted. One could hardly even call them neighborhoods but collections of shacks with tin roofs, no plumbing,

and uncertain electricity. The flies and the filth, the emaciated faces, and the packed slums were a disorienting experience. The wealth of the United States was displayed in vulgar excess by visiting crooks and businessmen who used the weary prostitutes that had to hang on to their abuser's money for survival.

Journalist David Detzer, after visiting Havana, wrote:
Brothels flourished. A major industry grew up around them; government officials received bribes, policemen collected protection money. Prostitutes could be seen standing in doorways, strolling the streets, or leaning from windows. One report estimated that 11,500 of them worked their trade in Havana. Beyond the outskirts of the capital, beyond the slot machines, was one of the poorest, and most beautiful countries in the Western world (according to *The Brink: Cuban Missile Crisis*, 1962 by David Detzer).

Joyce had never imagined anything like this back home, even with the substantial poverty of the Native Americans. It also helped her understand some of the malevolent aspects of United States policy and economic domination barely masking its colonial intent. Her experience shaped the progressive agenda she later pursued in the Oregon legislature. She realized what Arthur M. Schlesinger, Jr., had written about Cuba and the Castro revolution: "The corruption of the Government, the brutality of the police, the government's indifference to the needs of the people for education, medical care, housing, for social justice and economic justice...is an open invitation to revolution" (noted in *The Dynamics of World Power* by Arthur Meier Schlesinger, Jr.).

Joyce found new purpose from her travel. "The trip was a turning point for me. Havana was fascinating, but I was shocked at the working conditions at some of the hotels owned by US corporations. Cuban women in service at these American hotels – many of them

very young girls – were exploited and treated terribly. I had not seen that level of greed and corruption before."

This social consciousness would later influence her work as a legislator. She determined that, first, one had to see a problem and, then, learn the details of the causes and potential solutions to, finally, take the steps necessary. She began to learn that the choices a society makes in its politics and policy have a real effect on peoples' lives. While the well-to-do could be oblivious to the ills of poverty, those who were ignored suffered real consequences. The corruption of the rich taking advantage of the poor in business and housing, the Native people spurned and cheated, and the abuse of women struck her deeply. In the Midwest, she had seen a limited strata of society, and Cuba widened her vision.

Although most of Joyce's time spent as a tourist in Cuba took place in Havana, when she visited the countryside, she found quite a different story. In many ways, the rural areas reminded her of South Dakota. Families worked hard but shared their labor and their joys and losses. While they were poor, the poverty was not grinding. There was a community taking care of each other that enabled a dignity to life and the connection to the earth, the farming, and the husbandry that mitigated the paucity of material wealth.

"I was very impressed with the educational and health care systems the Cubans had developed," she shares. "I learned a lot from my time in Cuba that helped years later. The cooperative self-care of communities played an important part in making a livable society. Government can help or hinder. Laws can more equitably share resources among all classes and restrain criminal institutions organized around drugs, gambling, and prostitution. They can also ignore or even promote negative activities."

Observation and experience change the nature of purpose. For the first time, in Cuba, Joyce reflected on social conditions and government in supporting or challenging poverty. Her vision of her own nation and what it could represent was developed by questioning what it

promulgated in a poor and dependent country.

Though she spent only two weeks in prerevolutionary Cuba, her taste for travel had been whetted. Mexico seemed like the next logical excursion, but since Florida and Cuba had used up most of her savings, she had to first fill her coffer. She drove cross-country to Los Angeles, where she planned to regroup and figure out her next financial steps.

First, she found housing in Santa Monica with an acquaintance from Minnesota, through whom she quickly developed a social life – one that taught her another important life lesson.

Independent, Joyce was used to making her way alone. One night, she had an experience that taught her the importance of relying on others. She was out with some friends at a downtown bar and grill. Not yet twenty-one, she was under legal drinking age. A couple of cops entered, noticed her, and demanded to see her ID. They said they were going to arrest her, but Joyce and her friends had a bad feeling. It seemed like an arrest was merely a pretext to get her outside alone and into their squad car. It wasn't even clear if they were on duty. Two young men with her party stood up. "If you take her, we're going along," they insisted. The cops blustered, but these friends weren't going to let Joyce be hustled out by herself.

Finally, the cops let her go with a verbal "warning." Joyce was relieved and grateful. Without the help of others, she didn't know what would have happened. She realized not only the goodness and courage of others but also the importance of working together and standing up for what is right. The response of the young men left a deep impression.

With a bit of luck and her medical experience, Joyce was hired at a laboratory on the University of California campus (UCLA). This proved to be another turning point in her life and career – one that did not involve Mexico, as initially planned. Her lab work at UCLA became more involved and serious, leading to eventual employment with a major biotech firm. It was engaging and important. However, two oth-

er significant things happened at UCLA.

First, Joyce was in a fender-bender accident. She may have had mild whiplash, and her colleagues encouraged her to get a CAT scan – offered free to employees. What they discovered was that she had a cerebral arteriovenous malformation (AVM) – an unusual complex of tangled arteries and veins that can interfere with normal blood flow. It is usually a congenital deformation. Her doctor reported the malformation with a grave face. He briefly explained that she was at great risk for stroke and she should never have children. He prescribed a medication to prevent damage by lowering her blood pressure.

After a brief experience with the medication, Joyce discovered that it interfered with her thinking. This was not how she wished to live. She felt the message from the medical profession was "be afraid to live." Joyce wanted nothing to do with that. It was her life, and she was going to live it as she wanted. Her self-care from her early days made her balance medical recommendations with her own sense of what she needed. She was responsible for her life choices, not a doctor.

From that time, she has questioned and examined medical advice. This was not rejection of science but a refusal to have blind faith in medical establishments. She found that too often reliance on drugs and easy answers did not serve her well. Convention, guesswork, and bias could enter a doctor's judgment just like it could for anyone. She believed that patients should have access to as much information as the physicians. Joyce's belief to trust herself first and foremost was proven true when, years later, she refused to have her future be daunted by anxiety and gave birth to a son and a daughter – with no problems from blood pressure.

The other life-changing experience that happened while at UCLA was a blind date with an activist social worker deeply involved in civil rights, Stanley Cohen. Stanley was Jewish and came from a family radically different than Joyce's. When the family had dinner, they talked, argued, and laughed. She had never known meals could be like that. Joyce says, "They were much closer and more open with

each other than my family had ever been." For someone as bright and curious as Joyce, it was a greater discovery than Minneapolis or Cuba. It was a new life. Stanley taught and was engaged in social activism, but his father was one of those guys who never had a regular job; he collected items like stuffed animals and sold them out of his garage. It was a form of family unimaginable to a hardworking farm girl. By the early 1960s, she and Stanley were engaged.

Meanwhile, Joyce's work at UCLA became more involved. She was dedicated to the scientific method despite her disagreement with the personal medical advice she had received. She was involved in pioneering DNA research relating to a highly technical study on the effects of radiation on genetic structures, specifically how radiation affected the binding of hemoglobin to DNA. The blood of animals would be irradiated and then studied for deterioration. Once again, her farm experience with animals was useful. She was good at drawing blood from mice and the ears of rabbits. She also studied how they healed themselves. While she liked animals, she didn't romanticize them and felt their use in research was justified. Later in life, she teased her children about how they anthropomorphized their cats – a cat's job on the farm was to catch vermin, not to be a pet.

In 1964, she coauthored with Eric L. Nelson and published a peer-reviewed paper titled "The Effect of Radiation on the Deoxyribonucleic Acid-Binding Capacity of Hemoglobin." This work was part of the foundation for developments in cancer treatment. In time, she joined Nelson in the early days of Allergan, a pharmaceutical company. Joyce's research was involved in developing medication to treat glaucoma, high blood pressure in eyes. It was valuable work that led to advances in treatment, and Joyce was dedicated to the process.

Allergan began above a drugstore in the 1940s. In the 1950s, it expanded into a converted Los Angeles theater. The release of its first national product, a corticosteroid, turned it into a million-dollar company. In the 1960s, it moved again, to Santa Ana, Orange County. Joyce was part of the excitement of the burgeoning pharmaceutical indus-

try. Allergan's growth skyrocketed with antiviral drugs and ophthalmic products especially relating to the newly popular contact lenses. The company went public in the 1970s and was acquired by SmithKline in the 1980s. Botox became a flagship product, and the company later became involved in all sorts of combinations and spinoffs with researchers around the world.

Unbeknownst to her, Joyce's life was about to change again. Different players, a different setting, and a growing new purpose awaited her and Stanley.

CHAPTER 4
Awakening and Oregon

When Joyce got married, her parents came out to Southern California for only one day. They did not take part in sightseeing or any tourist activities, just the wedding and back home to the farm. It was like two worlds meeting or, in a way, the past meeting the future. Side by side, the two family cultures could hardly be more distinct. On the one hand was the gregarious, lively, interactive Cohen family that brought out Joyce's sophisticated engagement with society; on the other was the earthy, quiet, dour relatives who remained grounded in self-reliance and few words. She might not be able to mesh the two, but she could easily travel from one to the other. It provided Joyce with more bridges between different aspects of society and mirrored her later legislative ability to navigate the urban worlds of Portland and Salem with the rural eastern parts of Oregon.

It was around this time that Joyce felt enlivened by the prospect of having children. She and Stanley started their family in California with the birth of their son, Aaron, in 1963. Joyce fondly remembers having a convertible sports car she could tool around in. She would put baby Aaron in a little cradle on the floor of the front seat next to her. This was long before seatbelts and child-safety devices became common. As Joyce says, "Imagine anyone doing that now!" Their daughter, Julia, arrived in 1966.

Joyce loved being a mother; however, the children put a strain on the couple's relationship. Joyce was not going to be the stay-at-home mother that Stanley secretly wanted her to be. Joyce remembers, "I loved Stanley's family, but the fact that he and I were both committed to our careers was a problem for them." Stanley's resentment began to grow.

Their relationship wasn't the only source of tension at the time. Joyce had personally witnessed how the police force in 1950s Los Angeles was notoriously hard-boiled and corrupt. It was a time of official lawlessness toward the innocent and unprotected; tough guys took advantage where they could.

Chief William Parker had been brought in to clean up the corruption. He succeeded in professionalizing the department in some ways, but in others, the illegality continued in new forms. He worked closely with the popular police show *Dragnet* to create a tough but pious image of police as honest and fearless protectors. He was a major force in militarizing the police department, publicizing it in Hollywood as the "thin blue line" that saved Los Angeles from disorder, and promoting the traditional racism of the police. He did not hire Black officers, and white supremacists were not chastised during his tenure. Over fifty years later, all across the US, the kind of policing championed by Parker continues to cause protests and riots.

The sixties became an exciting time to be in California. Student activism fostered by the UC Berkeley Free Speech Movement, civil rights demonstrations, and resistance to the Vietnam War was burgeoning, buoyed by rock and roll and a booming economy. By then, Joyce and Stanley had moved to Orange County – a staunchly Republican and conservative part of California. They bought a newly fashionable Eichler house. These midcentury, single-story, sliding-glass-door houses were popularized in David Hockney paintings and a hundred television shows set in Southern California.

The community was an odd fit for Stanley's social work at UCLA and Joyce's growing social awareness; however, living there meant

more affordability for the growing family, a modern house, and at the time, an easy commute. There, they would host dynamic and rowdy dinners with students or their successors who would later form the Afrikan Student Union (ASU), previously known as the Black Student Union, which "was formed in 1966 to advocate for the needs and interests of all UCLA students of African descent" (according to the Afrikan Student Union at UCLA website, www.black-bruins.com). The ASU website states, "Its purpose was to increase the enrollment of Black students, as the Black population was comprised entirely of athletes at that time. The organization's founding was influenced by the increase in student activism brought on by the Civil Rights movement." Along with the poverty she had seen with the Lakota in South Dakota and the oppression and corruption in Cuba, these conversations were instruction for Joyce's future political action.

Revolution was in the air at those dinners. Los Angeles would soon be reeling from an event when all of this tension came to a head. The Watts Riot erupted the summer of 1965, partly caused by the policing Chief William Parker had strengthened. The Watts neighborhood had been deliberately formed as a ghetto after World War II through redlining, restrictive covenants, and all sorts of slum housing arrangements to keep the Black people who had come to Los Angeles to work in the war industries bottled up in poverty.

Unlike the open segregation in the South, which was increasingly protested with Freedom Rides and marches, the oppression in Northern and Western cities was less obvious and out of the public eye. It was no less cruel and harmful, however. Before the riot, Joyce and Stanley had been active in Watts, attending meetings, getting to know students and their families, and helping with organizing. Joyce found it informative and was glad to be of what use she could.

It was on August 11 that a traffic stop spiraled out of control. A mother was pushed by police, outrage sparked, and, as word spread, crowds grew. The police chief, who had spent years trying to reform the more blatant kind of corruption that Joyce had nearly experienced

firsthand in Santa Monica, determined that overwhelming force, militarization, and what he thought of as professionalism was the answer.

Thus began six days of confrontation, tear gas, live ammunition, looting, fires, and killing. By August 16, thirty-four people had been killed and over $140 million of property damage accrued. The National Guard was called in to "establish order." Chief Parker compared the riot to the Viet Cong taking over.

Over two hundred years of disenfranchisement boiled up and presaged the other protests and confrontations that would hang from the thread of US history like beads. These activities continued in different cities and at different times – in the 1970s, 1980s, 1990s (LA again, with the Rodney King riots), 2000s, 2010s and 2020 – with brutal incidents of authorities beating or killing people of color, protests and over-reactions, backlash, and handwringing. As with many other race riots, the causes of the Watts Riots were studied. Governor Pat Brown appointed the McCone Commission to report. It found that bad schools, poor job opportunities, crowded or defunct housing, lack of community health services, and hostile police-community ties had laid the groundwork. Nothing has changed.

Joyce and Stanley continued to be involved in the aftermath. Joyce remembers going to Watts to help with cleanup and trying to put together resources in whatever way a white outsider could. She saw that when the big picture is ignored and inequity allowed to fester, sooner or later there must be a reaction. The Black Panther Party (BPP) formed in Oakland in 1966, and many of the students and community members Joyce and Stanley knew were sympathetic, if not directly involved with the organization. The BPP called for employment, decent housing, equitable education, and prison reform. Especially noteworthy fifty-five years later was their call for "the immediate end to police brutality and murder of black people" (according to the *What We Want Now!* Ten-Point Program released in the 1967 edition of the Black Panther newspaper). Several notable members of the party were assassinated; their deaths tragically resonate with contemporary gov-

ernment and police violence.

So much was happening in Joyce's life, with work, her social involvement, and her family. While Stanley was the primary activist, Joyce, with two young children, was relegated to being the primary parent. She continued her laboratory work at Allergan in a pattern now familiar to two-working-parent families where the wife bears most of the childcare. Parenting, done well, requires purpose, focus, and practice.

By 1970, Stanley had gotten job offers in Georgia and Oregon. Joyce favored Oregon because of the possibility of owning land and holding on to echoes of her childhood for herself and her children. It was time to make a change and escape Orange County. Stanley was hired as a director of a teacher training program to increase African American presence in public schools.

Oregon in 1970 was still primarily a rural and agricultural state. Its main industries were timber, grain production, the outdoors, and fishing. Companies like Intel and Nike were in their infancy. High tech was only in gestation. Portland was a backwater compared with Seattle and San Francisco, with a long history of on-again, off-again civic graft and poor governance. At the turn of the twentieth century, the city had been run by influential and, often, corrupt families.

Oregon was built of paradox. It became a state in the 1850s to support the Union, backed by the antislavery Northern states, and then became a home to the KKK and Southern secessionists after the Civil War. Conservationists fought the timber barons. Liberal cities like Portland and Eugene struggled with the rural eastern part of the state and expanding suburban areas encroached on farmland. Native peoples were excluded while being mythologized. Tourists were welcomed and then urged to go back home. The environment was worshipped, while dams and river pollution and savage clear-cut forests were hidden.

Feeding these paradoxes was progressive legislation from 1898 and 1906, introduced by the influential legislator William U'Ren, that

helped redefine the state. It was called the Oregon Plan and included a statewide initiative whereby citizens could propose laws and referendums on current laws and recall elections for political officials. After passing in Oregon, these procedures became widely adopted across the country. U'Ren also fought for direct election of senators rather than their selection by electors or the legislature. This legislation built a political culture in the state that was independent and generally progressive, though always pressured by timber, wheat, mining, and shipping industries – and a long, long history of virulent racism.

African Americans were written into the state constitution with restricted rights – initially it had been proposed to exclude Blacks entirely from the state – and there had been violent repression of Asian American workers. Even in relatively liberal Portland, there were the same restrictive covenants as elsewhere in the nation.

One unique area was the public housing community known as Vanport (a combination name of the cities of Portland and Vancouver, Washington). Built in a low-lying area along the Columbia River in 1942 to house World War II workers in the Kaiser Shipyards, Vanport at one time sheltered as many as forty thousand residents, almost half of them African American. At the time, it was Oregon's second largest city. The housing authority neither supported nor opposed racism, and there was considerable integration in the development but also the implicit hostility between the races that was common at the time. It was a transient community where workers (and after the war, veterans) moved in and out of the housing, and this movement failed to create strong community bonds. Vanport suffered a devastating flood in 1948, destroying the community, killing fifteen, and leaving 17,500 homeless. The subsequent migration out of Vanport had mixed consequences for integration in Portland. It broadened the racial mix of the city, but it also created a new ghetto in North Portland due to restrictive covenants. Oregon was, and remains, one of the "whitest" states in the country.

To realize the farm connection Joyce wanted, the family bought

a forty-acre hazelnut farm in an agricultural region near the town of Dundee. Joyce was not employed and more than capable of managing the orchards. Stanley also became enamored of the outdoor work. He continued his social work and advocacy with students of color at the University of Oregon and the civil rights issues that arose in Portland, Eugene, and Salem but would happily retreat with Joyce to farmland.

The hazelnut, also called the filbert or cobnut, is grown worldwide. It was mentioned in a Chinese manuscript as early as 2838 BCE, where it was called one of the five sacred nourishments. The ancient Greeks also believed it to be a tonic and a medicine (www.oregonhazelnuts.org). Probably introduced to Oregon by French settlers, the hazelnut became the official state nut in 1989. Joyce would later become part of making this designation.

Oregon hazelnuts were on their way to becoming an important crop in the world market; later, when Joyce became a legislator, she championed changing the official name of the Oregon product from the French name, "filbert," to the more English "hazelnut." Although Turkey produces the majority of hazelnuts, by 2020, Oregon represented between 3 and 5 percent of the worldwide harvest.

Because hazelnuts are relatively easy to grow in Oregon in a variety of soils and because Joyce did not need to make a living from the orchard, it satisfied her need to stay connected to her farm background. The fertilization, irrigation or pruning needs could be met by the whole family. Later on, when she was in the legislature, it contributed to her interest and support of the crop for Oregon.

In addition to Joyce and the children's regular trips back to the South Dakota farm, the hazelnut farm helped to confirm a connection with nature that was so vital to Joyce and her children – there was harvesting the orchard, vegetable gardening, hoeing and canning everything from potatoes to hazelnuts, and tending to chickens and farm pets. The children have happy memories of these visits; her daughter still keeps a pair of her mother's cowboy boots on a shelf in her office.

The move to Oregon began a new chapter in Joyce's life. The

move spurred her engagement with social and political concerns. It was a time of a strengthening feminist movement. Joyce had always been what she calls "uppity"; her independence in high school, her move to Minnesota, the development of her medical career, her explorations in Cuba, and her disavowal of the medical advice shoved down her throat at UCLA all contributed to the making of a strong, independent woman. She could see that women in leadership roles were still rare, but the second wave of feminism was raising awareness of the dearth of women in position of power in politics and in business.

Oregon is, after all, known for its pioneers. There were many strong women in the state, such as Tabitha Moffatt Brown (the "Mother of Oregon," as the state legislature designated her), who migrated in 1846, built a glove-making business, and founded an orphanage and the Tualatin Academy (now Pacific University); Sarah Winnemuca, a Northern Paiute, who worked in Nevada, Oregon, and Washington as a military scout and interpreter, who championed before the US Congress the rights of imprisoned Paiutes, and who later became the author of the first known autobiography by a Native woman; and the suffragist Abigail Scott Duniway, who addressed the all-male Oregon legislature in 1872 when other women were afraid to accompany her, continued the fight for suffrage despite strong opposition until 1912 when Oregon became the seventh state to support women's voting rights, and published numerous books; among many, many others.

On the more modern political spectrum, from 1955 to 1975, Edith Green became the female congresswoman from Oregon, whom Senator Hatfield called "the most powerful woman to serve in the Congress," (according to "American Memory," *Women in Congress*, Library of Congress). In 1960, Maurine Brown Neuberger served as the first female senator from Oregon and noted the difficulties for a woman politician: "Before she puts her name on the ballot, she encounters prejudice and people saying, 'A women's place is in the home.' She has to walk a very tight wire in conducting her campaign. She can't be too pussyfooting or mousy. Also, she can't go to the other extreme – bellig-

erent, coarse, nasty" (*Women in Congress, 1917-2006*, p.338).

Mercedes Deiz became the first Black district court judge in 1969; Betty Roberts became the sole female in the state Senate, later appointed to the Oregon Court of Appeals and the Oregon Supreme Court; and in 1976, Norma Paulus became the first woman elected to statewide office, as the secretary of state.

Change was in the air, not only in politics but in business and the arts. In 1969, Ursula K. Le Guin became the first woman to win the Hugo and Nebula Awards for *The Left Hand of Darkness*, a book that explores gender identity and that stunned the science-fiction world with its bold expression of feminist ideas. Gert Boyle, who had immigrated from Nazi Germany in 1937, took over Columbia Sportswear in 1970 after her husband died of a heart attack. After struggling for a number of years, she built the company into a clothing powerhouse.

Still, patriarchal males also used the word "uppity" (and still do) to describe outsiders who want to share power and influence. It was the same word used to describe free Blacks trying to claim their rights and fortunes after the Civil War. Joyce was not one to be daunted: to be uppity was a badge of honor. She had tasted it at the medical college, stumbled across it as a waitress in a Florida resort, seen its effects in Cuba, and felt it in the medical advice and laboratory work at UCLA. It also ironically affected her marriage, despite Stanley's penchant for left-wing politics. Patriarchy has deep roots. Instead of intimidating her, it made her stronger, more confident, and more assertive.

PART I LESSONS

What conclusions did Joyce reap from the first forty years of her life? Here are some of the lessons mastered:

Work with what is at hand.
On the farm and in the laboratory, resources may be limited, but tasks still need to be accomplished. Look around and make use of whatever is available, even if it seems an unlikely resource.

Take the time to do the work and do it right.
This means digging down and learning the details. On the farm and in the laboratory, sloppy work can have serious consequences. Plus, having to do over what could have been done right the first time is exhausting. Don't be afraid to shovel grain all day if that is what is necessary.

Learn by doing—be practical, not ideological.
Focus on what works, not on what could or should work. The process of understanding is built by trial and error and making the effort to try. At their heart, farming, medical science, and even raising a family are practical pursuits. The idea of grain does not feed, the idea of surgery does not heal, and the idea of guiding children does not teach – only the doing works.

Use your own observations; figure out by yourself how to do something.
Early on, Joyce inculcated self-reliance. First, see a problem and then, learn the causes and details of it. Others can contribute experience and wisdom, but they can't replace your own vision. Work out solutions to cleaning the calf's foot or how to travel to a foreign land and then implement your decisions.

Take in the larger picture.

The common saying is not to forget the forest for the trees. Joyce always sought to see the bigger picture: the experimentation on animals that lead to medical breakthroughs, the patterns of exploitation that corrupt a society, and the social ties that bind communities together. The consequence of focusing too narrowly and ignoring a larger purpose is that winning a small victory may set back a larger goal.

Take care of and heal your body.

No one else is responsible for your health choices. Doctors are not dictators, and you have to determine what works for your body and being.

Follow a code of morality and absolute honesty.

Many elements of work and self-reliance depend on the inner strength to remain faithful to a moral core. Similarly, Joyce learned in her budding activism that strictly keeping your word and being as honest with others as possible created an environment for success.

Accept the help of others.

When the young men in the bar stood up for Joyce against the corrupt policemen, they worked out of a sense of decency and fairness. In the farm and in the laboratory, teamwork is the necessary counterpart of self-reliance.

Overcome fear of the unknown—be a pioneer.

The unknown — an attic room in high school away from family, a blind journey to Minneapolis, a solo venture to Cuba, a marriage to a man from a different social and cultural background, even a move to Oregon — offers opportunities to learn and adapt. Master inner doubt and stay open to what may happen.

PART II
ACTION

CHAPTER 5
Activism

R alph Waldo Emerson noted that as we look forward, our lives may seem erratic or uncertain, but when we look backward, a pattern emerges. He likened it to a sailboat that tacks this way and that to reach its destination; whether that path is predestined or based on each choice as we proceed is a question that has challenged philosophers for eons. Certainly, character shapes choices, and choices also shape character.

In Joyce's belief in purpose, focus, and practice, the interplay of character and action is clear. Her childhood desire to tend to people or animals grew from farm life, to medical and research work, to family, and now – to her political engagement. If purpose was formed in this way, so too were focus and practice. She learned early on that each farm task required focus: shoveling grain or feeding animals could be dangerous if not done consciously. Medical research required precision in ensuring that the oxygen level of a patient in surgery was exactly monitored. Naturally, repetition and dedication in carrying out both planning and action enabled her purpose to become realized.

If she had not grown up socially isolated, would the desire to escape the rural life and experience a wider world have been as strong? If the silent and even repressive family life had not predominated, would the voluble sociability of Stanley's family and the boisterous

social work with the Black students been so attractive? If not spurred by the civil rights movement and the tide of feminist activism, would her assertiveness in the face of patriarchal tradition and her next stage have developed as strongly as they did?

The family's move to Lake Oswego, a Portland suburb, catalyzed a change in Joyce's life as unexpected and daring as her escape to Minneapolis, her exploration of Cuba, or her marriage to a social activist. Changing our environment tends to lead to other changes in our lives. While Joyce retained purpose in her life as a wife and mother, she found a need for a greater purpose.

As the children grew older and the family settled in, Joyce became interested in the community. She was not working at a job, and the hazelnut orchard did not need full-time attention. Instead, she took notice of other areas in her life: the natural world, land use, health care, and the political action that supported social change.

Lake Oswego is moderately upscale and in the 1970s was beginning to experience the growth that the rest of Oregon was also undergoing. Not as conservative as Orange County had been, it was still quietly Republican. Nearby was the older community of Oregon City that had once vied with Salem and Portland to be the capital of the state. Protests against the Vietnam War continued and would soon help to bring down another presidency, first Lyndon Johnson's and then, in a different way, Richard Nixon's. Preservation of the environment was gaining momentum after Rachel Carson brought it to people's attention with her book *Silent Spring*, that highlighted the devastation caused by the pesticide DDT. Given her rural childhood and the social consciousness that had developed with her husband, it was natural that Joyce would become involved. She turned her attention to local and state issues that addressed the health of the community and the health of the land and joined organizations dedicated to justice and preservation of nature.

One concern was the commissioning of the Trojan Nuclear Power Plant, a pressurized water reactor on the Oregon banks of the

Columbia River. Construction had begun in 1970, despite considerable worries about the design, and the plant went into operation in 1975. Joyce had joined the opposition that visited the site and protested the operation of the reactor. She worked with neighborhood, state, and national organizations in fighting the plant. Trojan was shut down in 1978 because of construction errors and the discovery of an earthquake fault nearby. Although the plant was restarted, it continued to leak radioactive material and have other problems. It was closed by Portland General Electric (PGE) in 1992 and permanently decommissioned in 1993. She proudly remembers later being awarded an office chair as a memento of her involvement when the plant was closed,

A problem closer to home arose in Lake Oswego. Joyce relates, "I got involved in a local issue that developed into a whole new career for me. The issued involved both land use and open meetings." Already faced with the stress of a move and buried resentment about her working, Stanley was not pleased with this new passion. Joyce was not deterred.

The issue was that Lake Oswego land was granted to a local country club. This might have been reasonable and judicious; there was no way to know. The discussion and decision by the city council happened in a private meeting. On the surface, it smelled of corruption or self-dealing not in the public interest. It didn't seem right.

"I was disgusted when I found out that the council was making their decisions in closed meetings and that it was actually legal," Joyce remembers. "One of my neighbors was already an activist." After futility at the local level to get the process changed, she decided to go to the state capital and push for a new law. Public property decisions needed to be made publicly, she felt. This meant that proposals had to be aired in advance and with enough time for response; that meetings had to have agendas and minutes; and that provision for written or oral testimony to the proposal must be made. Sunshine, she thought, would be the best disinfectant.

"I met with legislators and lobbyists, anyone with any power.

I was very determined. I worked with politicians on both sides of the aisle – something I always continued to do. I became friends with the state senator Vic Atiyeh, a Republican who would soon be elected governor. People started thinking of me as someone who could get things done." In 1973, the Oregon legislature, urged on by other female legislators like Norma Paulus, passed a public meetings and records law requiring open meetings for all public bodies, from city councils to the legislature itself.

The victory, hard-fought, fueled Joyce's appetite. There were so many other issues that demanded attention. While Joyce could be intensely focused on one issue, she always connected it with a larger purpose of a more just and caring society. It was not only Lake Oswego but the whole state of Oregon that needed change. In the process of getting to know local and state legislators and constant trips to Salem, she discovered how to effectively lobby. Exasperated, Stanley harrumphed, "You're spending so much time in Salem – why don't you run for the legislature?" Joyce found the inspiration to run for office from allies and politicians, lobbyists and community organizations, as well as the gibe at home.

Another issue arose in neighboring Oregon City. Oregon City was struggling to preserve its history. It was considered the end of the Oregon Trail and an important part of Oregon history and the settling of the West Coast. But many other localities wanted recognition for their part in settlement as well as federal dollars that went along with that national validation.

The trail was forged by the Lewis and Clark expedition and John Jacob Astor's establishment of a West Coast trading post at Astoria. Settlement of the Northwest became increasingly important for several reasons after 1830. The dispute with Great Britain over the boundary between Canada and the Oregon Territory required an American population in place. What is now the state of Washington was particularly contested. The Hudson Bay Company exerted a pervasive economic influence over that area, and that trade benefitted Britain. Settlement

also could counteract British and even Russian fishing and whaling industries controlling convenient ports and prevent their domination of the sea. Even more important was the gnawing question about the extension of slavery.

A series of agreements – the Compromise of 1820 and the Missouri Compromise – tried to balance the economic and political power of the Southern slave states and the Northern free states. The Southern plantation economy based on cotton and slave labor resisted the trade imperatives of Northern industrial interests. The South feared losing its human property and the spread of abolitionism. The North was repelled (to some extent) by the horrors of slavery and the free labor it represented.

The power brokers of the South, most represented by John Calhoun, determined that there should be no impediment to slavery in the land acquired in the Louisiana Purchase. The North determined that slavery should not spread. The defeat of Mexico in the Mexican American War, the addition of Texas as a slave state, and more territory to settle in Missouri, Kansas, and Nebraska all made calculating the legislative power-sharing between the regions more and more difficult. The series of carefully balanced (and eventually futile) compromises meant that each addition of a slave state required a corresponding admission of a free one. The situation was further complicated because the South initially thought that adding a number of new states would increase their control of the Senate and presidency.

The country was dedicated to expansion. The United States was founded in acquiring and developing real estate. For many reasons – the opportunity to own land and be self-sufficient, to escape the density of cities and new immigrants, to generate capital through sale or rental of land, or to expand market control of agriculture – the burgeoning population of the continent was land crazy. Supported by the press and politicians, the ideology of Manifest Destiny proclaimed America's God-given right and its necessity to expand. The domination or removal (including genocide) of the indigenous peoples, often sim-

ply labeled as savages, was justified also as a God-given right of "higher" civilization. Western migration, first across the Allegheny mountains, then to the old Northwest Territory, across the Mississippi and south to Texas, was integral to the structure of the United States. There was even an undercurrent for possession of Canada, Mexico, and Central and South America. In 1848, with the discovery of gold in California, a wild rush farther westward began. The journey by sea using the portage across the isthmus of Panama or, dangerously, around South America's Cape Horn was difficult, expensive, and time-consuming. Land routes could allow a broader portion of society, including families with their wagons of household goods as well as solo pioneers, to migrate. The Oregon Trail was one of the major routes.

The trail started in Missouri, and as it headed west through Kansas, Nebraska, and Wyoming, it shot spurs off into Utah, Montana, Idaho, and Washington. But where did it end? Early on, settlers were stymied when they got to The Dalles, Oregon, because there was no wagon trail around Mount Hood (known as Wy'east by the Native population). They were forced to take to the Columbia River to reach the fertile Willamette Valley or try to cut their own perilous way through forest and precipice. Because of increased need, the Barlow Trail and others were built to offer wagons a way forward for the rest of the journey.

Oregon City on the Willamette River had generally been considered the end of the Oregon Trail. Then other localities in Oregon, most prominently the city of The Dalles, and even Washington put up declarations averring that they were the end of the trail. Joyce became involved in the controversy. With local support, Joyce proposed and got passed legislation determining that Oregon City was the official terminus. (There is now an End of the Oregon Trail interpretive center where commemoration of the experience, along with educational and cultural programs, is a regular feature in the town.) Almost fifty years later, Joyce remains connected to this effort.

Another concern that inspired her involvement with politics

was the environment. Naturally, this was important to a farm girl from the Dakotas. National awareness, spurred by the first Earth Day in 1970, focused on the preservation of forests, watersheds, and the vast variety of species in the northwest from salmon to sage grouse (all of which were under assault from spreading civilization), careless overfishing and over-logging, toxic waste and chemicals, and the Depression-era enthusiasm for dams that provided cheap and necessary hydroelectric power. Joyce was interested and concerned in many areas. A key question now was how to preserve farming, ranching, and timbering land from the pressures of increased urban populations and economic growth while balancing these competing interests with conservation.

As she spent more and more time away from home, her marriage continued to fray. Traveling about the state to understand the issues, heading to Salem to lobby, joining the American Civil Liberties Union (ACLU), where she later became a director of the state branch, and meeting with community groups took time. Work on the hazelnut farm and vacations with the children back to the South Dakota farm mitigated some of the family's loss of Joyce's presence, but it was difficult. Stanley was also engaged with his work guiding social and educational programs.

The shift in attention from family to politics was vivid. The family's whole life began to revolve around politics. Yard signs were silk-screened at home, and piles of envelopes had to be sealed and stamped. Joyce would canvass seven days a week and often was not home to serve the TV dinners the children ate. Her daughter missed her mother's latkes (potato pancakes), which she would share at school. Now Joyce was absent much of the time.

Finally, in 1976, she ran for a House seat in the Oregon legislature. Lake Oswego was a Republican-leaning district. Joyce ran as a progressive Democrat against the well-established conservative Republican politician, Roger Martin, who was a longtime incumbent and a Republican leader of the House. She lost. However, the vote was surprisingly close and led her to make a big decision: "I decided to run

again in two years, in 1978."

For someone with Joyce's mantra of purpose, focus, and practice, failures are learning experiences. She says, "I liked campaigning – going door-to-door and meeting people at their homes, holding coffees, attending meetings. I enjoyed all those things." Campaigning was an example of practice. The more you did it and the more familiar you got with who to talk to and how to talk to them, the more effective you became.

Even without massive TV advertising, money was needed to fund a campaign. Joyce's resources were modest – yard signs, mailers, refrigerator magnets with emergency numbers (including Joyce's name and campaign information). In all her printed materials, she made sure that there was useful information for the voters. She had to learn how to use the phone effectively as a politician and what meetings to schedule with supporters. Getting to know the most important person to talk to at the Better Business Bureau, the local Rotary, the Elks association was valuable learning that would later help in talking with legislative colleagues.

Her Rolodex grew. She met with other women who were beginning to pursue political aims and joined more groups. The time spent going door-to-door talking to constituents proved critical. Always a good listener, Joyce discovered how important health care issues were (and remain) to most voters, especially women. Other local issues like zoning, traffic control, the Department of Motor Vehicles, property taxes, and school issues at the primary, secondary, and college levels were brought up. Most of the issues needed steady funding or prioritization. Health care was a broad concern and second only to the environment.

Joyce notes, "My campaign was one of the very first to use computer technology to produce a total picture of the district. I discovered that protecting the environment was the number one issue for most voters in my district [including the communities of Oregon City, West Linn, Milwaukie, and Lake Oswego], no matter what their party affiliation. That became one of my key issues – clean air and water." This

meshed with her early opposition to the Trojan Nuclear plant. Environmental issues and health care were starting to claim more legislative attention in Oregon and nationally. President Nixon had even signed legislation that formed the Environmental Protection Agency (EPA). A dawning awareness of disappearing species, acid rain, fouled water, and the dangers of chemical poisoning of the planet got the attention of the public and lawmakers. There was concern about the ozone layer, and even the build-up of CO_2 in the atmosphere that was leading to higher air and water temperatures. There was a need to clean up seriously polluted sites.

Also under Nixon, insurers and health care organizations like Blue Cross Blue Shield were given license to privatize. Without restraint, corporations could turn the health care that had long been protected from profiteering into a money-making proposition. Since the United States had long avoided any sort of national health care, this opened the way for the disaster that it has become. (The opioid crisis of the 1990s and again in the 2010s and the coronavirus pandemic in 2020 were almost inevitably going to become lethal when short-term profit-making forestalled any long-term restraint or preparation for corporate greed and political miscalculation.)

Some states, such as Oregon, realized the health of their citizens would require leadership at the state rather than the national level. The degeneration increased under the Reagan administration with the withdrawal of funding for mental health that ended up turning the mentally ill out of institutions and onto the streets, homeless. Joyce's background and interests had prepared her for these concerns.

She ran for the legislature again in 1978. Her former rival, Roger Martin, had decided to run for a state Senate seat, leaving her an easier path to election. (Martin won the Senate seat.) Joyce remains friends with Martin and still meets with him forty years later; early on, she demonstrated her practice of maintaining friendship with political rivals. This time she won the election. And did so in 1980 and 1982.

CHAPTER 6
Communication
and Alliance

So many initiatives that Joyce successfully took up when elected to the Oregon House of Representatives were initiated in the mid-1970s, including land use legislation. The major issue in Oregon was how to provide a measure of planning for both urban and rural areas to balance competing needs of these regions. Protecting farm and forestland from unrestrained development required some restriction for urban growth at the same time as accommodation for cities to grow and expand.

Joyce traveled to the rural eastern and southern parts of the state to become informed about the concerns of these mostly conservative communities. It could be tricky telling farmers and ranchers how the use of their land might be constrained. Explaining the needs and benefits of land planning went hand in glove with listening. Once again, her background in South Dakota enabled her to more quickly perceive the issues and to communicate in a way that someone with no country experience could do. This was especially helpful in dealing with representatives and senators from sparsely populated parts of the state, the "good old boys."

First, however, Joyce needed to position herself as a serious leg-

islator. While there were women who had established themselves on the national or regional stage, politics in Oregon was still primarily a man's game. As a woman of vision and energy, she wasn't going to constrain herself to patriarchal expectations.

She says, "I knew I was going to be closely watched as a Democrat elected in a district that had long been represented by Republicans. I got an appointment to serve on the House Judiciary Committee. I would be the only woman and the only non-lawyer to serve on this committee. I realized that other legislators, lobbyists, and the press would be following my every move, some watching to see if I would fail." Other women legislators at that time experienced similar scrutiny. Betty Roberts, the first female judge to the Oregon Court of Appeals, faced both subtle and distinct discrimination from some of the male justices.

Joyce's mantra of practice became paramount. She used the discipline learned on the farm and in her medical work to study the legal system at night. "I needed to prepare if I wanted to be effective. I got a law dictionary and studied how to use it. I learned legal terms so I could discuss legislation with all the lawyers on the committee in their own language." She even brought legal tomes to meetings. It wasn't long before most people assumed that she had legal training; "people who watched meetings were surprised when they found out I wasn't a lawyer." She still has her legal dictionary. Eventually she became chair of the Judiciary Committee.

One thing she realized early on was the importance of looking the part. "I didn't want to be thought of as a floozy," she says. She created a look – a man's white dress shirt with a bow tie and vest or suit jacket. That became her signature outfit. Appearance was part of her strategy and served a greater purpose.

On the Judiciary Committee, she quickly realized that the senior members were having her ask all the difficult questions whenever there was a judicial nominee. Either because the older men were friends with the person or because there was a political downside to

certain questions, they let Joyce take the heat. This was a learning experience. However, once Joyce understood what was going on, she would sit silently and force the other committee members to do their duties.

Other female politicians were getting elected to the legislature. She formed a close relationship with these women who were also breaking into politics. Jane Cease, who became a close colleague, and Darlene Hooley were elected as state representatives around the same time. Hooley later became a representative to the US Congress. Naturally, these women shared some common interests and met to discuss aims and strategies. Included in these rising female voices were Republicans as well. Their camaraderie and mutual understanding of how to work helped them form alliances and co-counseling on initiatives.

Initially, Cease remembers, both men and women were a little nervous about female politicians. "Shouldn't they be home taking care of the children?" some of the men thought even if they didn't say it out loud. Women were beginning to feel empowered, but entering the halls so traditionally male made them a little uneasy. Soon they got over their awe. Nationally, the women's movement was beginning the long process of overcoming barriers to involvement in politics, business, the arts, and even sports.

Cease had an experience similar to Joyce's when she began serving on the transportation committee. Whenever the chairman called on her, he did not use the protocol of saying "Representative Cease." This meant that in the official record, she would not be noted. He would nod or gesture to her instead. It wasn't until months later, after she had done extensive background on a bill and was able to demonstrate details that the chairman himself had forgotten, that he began to pay her the respect of using the appropriate title and recognition. Joyce's no-nonsense reputation meant that she experienced relatively less of this type of put-down.

Cease remembers that their offices were close to each other in

one corner of the fourth floor. She, Joyce, and Vera Katz were next to each other. Katz preceded Joyce in the House by six years (elected 1972) and eventually became the first woman Speaker of the Oregon House. Later, she became the culture-changing mayor of Portland, helping to transform it from a sleepy backwater to a vibrant, dynamic, youth- and environment- oriented city, from 1993 to 2005. Naturally, there was much passing conversation and overall sharing in addition to working together on such transportation items as opposition to the Rose City freeway. An early struggle together was overcoming conservative Democrats who were against electing the more progressive Hardy Myers as Speaker of the House. It took six weeks before Myers was chosen; Joyce had been a staunch, tireless supporter.

To begin a legislative career is almost overwhelming. According to Cease, "You don't know what's going on at first... The whole world wants to get in your door. You have colleagues trying to pressure you. You have a nonstop schedule. I would get to the office at 6:45 in the morning to work. [There would be] a committee meeting at 8:00, then a floor session, lunch, an afternoon committee meeting, then work on reading bills until sometimes eight, nine, or ten at night. You think of it as a little more glamorous, but it's a lot of hard work." Because of shared purpose and the proximity of offices, she and Joyce became close friends and collaborators. Cease pays tribute to Joyce as a unique freshman legislator. Her dedication was recognized at once. Myers made the unusual choice to have Joyce become the chair of a committee. It was not only a reward for her effort on his behalf but acknowledgment of her skill and commitment to legislating.

The groundwork in the legislature was done in committees. That's where testimony was heard and questions asked. It was critical to have a buddy that you trusted on issues sitting on a different committee. What did your ally think about this? What was really going on? What needed to be done, and who was trying to do it? You might not go along with your partner, but you had a clearer idea of what was happening in the bigger picture and who was affected. Another im-

portant function was warning your friends if you changed your mind about an issue, so that your vote would not catch them by surprise. Cease notes, "That's the real story of what is behind a bill. A lot of it is just learning about dependability and Joyce was eminently dependable. Joyce was particularly heroic." Usually, legislators go along with the manager (that is, the Speaker of the House) on matters, but Joyce also had the backbone to stand up to them.

A pair of boxing gloves hanging on the wall of Joyce's assisted-living room exemplifies that valiant spirit. One of her first legislative accomplishments wasn't one that would seem naturally to be a "woman's issue." In her discussions around the state, she had found out that there were unregulated boxing events where young men were getting seriously injured. These weren't necessarily secret fight clubs but public events that did not have any rules or protections. Therefore, she helped fashion legislation to provide a measure of protection and safety for these bouts, covered by Chapter 463 of the state code.

She brought so much of what she had learned in childhood on the farm about persistence and the need for hard work to the beginning of her legislative work: long days of doing what needed to be done and generating her own solutions to problems. She also found that her scientific research work enabled her to pay attention to details and know how to put these details together to create a larger picture. She found that other legislators could see the big picture but relied on aides and lobbyists to understand and come up with fine points. Laboratory work was not done in this way, and neither should legislation. Joyce dug into the statistics, references, and opposition views on each topic. In this way, practice helped foster her focus and strengthen her purpose.

When John Kitzhaber, later a president of the Oregon Senate and three-term governor of the state, started in the legislature, Joyce adopted him and another young freshman who also developed a strong career, Bill Bradbury. "Her boys," she sometimes called them. One day, during slow and bureaucratic maneuvering, she saw them

fooling around. "Two of my colleagues in the House...were playing with a little rubber duck on the House floor while we were in session. I went over and told them that they needed to cut it out." Joyce tapped John on the head and took him aside. There was a large, old, wooden phone booth just outside the chamber that members could retreat to for a private conversation. Like a farm mother taking a truant to the woodshed, she let him know that this behavior was not okay. Then she took Bradbury out to the shed too. They laugh about it to this day. Joyce says, "I worked on establishing good relationships in the legislature, and I took my work seriously." This marked the beginning of a close working relationship with Kitzhaber and Bradbury.

John Kitzhaber was the image of a charismatic western politician. Ruggedly handsome with piercing blue-green eyes, sporting denim jeans with a sport coat even at official functions, he had received an MD from Oregon Health Sciences University (OHSU) in 1973 and begun practicing medicine as an emergency room doctor in Roseburg, Oregon. Early on he was interested in public health issues. It became natural to run for the Oregon House of Representatives. Colleagues, especially women, found him magnetic, and he quickly rose in power to serve as the Senate's president for eight years. His involvement with the Oregon Health Plan gained widespread attention, and he was beginning to have a national reputation as an up-and-coming Democratic politician. Even before the Democratic governor, Barbara Roberts, decided not to run for reelection, Kitzhaber had planned to challenge her. When she stepped aside it helped him win the ensuing election.

For the next two terms, Kitzhaber served as governor, supporting and extending many of the policies that he had worked on with Joyce. He supported comprehensive land use planning, further development of public health including the Oregon Children's Plan, and environmental protection for salmon and the regional watersheds. He was a popular governor and easily won his second term. He could not legally serve a third consecutive term under Oregon's constitution and returned to private life.

In 2010, however, he returned to politics, winning the Democratic primary over his former colleague in the Senate, Bradbury. He went on to win an extremely close election and become Oregon's only three-term governor. He earned significant headlines by commuting the death sentence of a murderer who refused to be pardoned. This led to an extended legal struggle in which Kitzhaber prevailed in not carrying out the death sentence. One of his greatest regrets had been going through with two death sentences in his first term. Late in his term, concerns arose about his relationship with Cylvia Hayes, who was serving as First Lady and was his fiancée.

Kitzhaber ran again in 2014 and began his fourth term as governor. However, scandal continued to swirl about Hayes and her use of influence for political gain. A federal investigation into influence-peddling increased the pressure. Kitzhaber's Democratic colleagues in the legislature urged him to resign. He did so in February 2015 without admitting any guilt. The federal investigation was later dropped, but both he and Hayes had to pay hefty fines levied by the state Ethics Commission.

After he stepped down, Kitzhaber returned to the public health initiatives he had pursued as governor and in between his years of service. He began the Archimedes Movement (now, We Can Do Better), an organization that promotes using public resources to support widespread health care. He served as the director of the Center for Evidence-Based Policy at OHSU. A supporter of Bernie Sanders, he has not ruled out running again for public office.

The other mentee and colleague of Joyce was Bill Bradbury. Bradbury began his career in the Oregon House later than Joyce and Kitzhaber. He came to the Senate in 1984 and gained leadership positions within it, including president in 1993. In 1999, appointed by Kitzhaber, he began serving as secretary of state. He successfully implemented Oregon's all-mail-in election voting system, the first in the nation. He ran for US Senate in 2002 and lost, as noted before, in the 2010 Democratic primary for governor to Kitzhaber. He was succeeded

in the secretary of state post by Kate Brown, who would become governor upon Kitzhaber's resignation.

Even before working together in government, Joyce met Kitzhaber in her environmental and health care work. Like most Oregonians, she held the outdoors as a significant concern. Kitzhaber's work as an emergency room doctor and love for the natural beauty and resources of Oregon made it likely that they would have become acquainted. Saving the once mighty salmon fishery became (and remains) an important Northwest concern. Fish stocks that had once been so plentiful that locals could boast walking across the Columbia River on the backs of salmon had plummeted from the series of dams, overfishing, and pollution. Protection of the state from the massively dangerous contamination from the Hanford and Trojan nuclear sites was also part of Joyce's early environmental vision. Another issue that later became a hot topic was some means of providing health care access to the impoverished. With her medical background and care for others, it was natural that Joyce should gravitate toward these issues.

Making good legislation is a communal activity. Different visions of policy are represented by different voices. In addition to the concerns of party and caucus, there are the needs and demands of the constituents. As a progressive Democrat committed to providing governmental services to the community, Joyce was a natural opponent of the tight-fisted, small-government ideology of conservative thinking that was primarily concerned with lowering taxes and increasing benefits for businesses. But politics is the art of the possible, not a game where one side achieves a perfect, ideological victory. It requires research on many views and consultation as widely as time allows. It rewards holding a position yet swapping and compromising. It calls for a sense of when to strike and when to pause. In the new century of hyper-partisanship and shrill calls, listening and balancing the big-picture ideal with reality is even more important yet these conversations have become increasingly impossible. Throughout history, contentious issues arise and how a leader meets these social challenges determine

success. One noted model of wise guidance comes from ancient history.

In ancient Greece, Solon became known as one of the seven sages because of his masterful solution to an intractable political problem. Athens had been beset by decades of strife between wealthy landowners and impoverished peasants. Generation after generation of poor farmers had fallen into the crushing debt slavery that threatened the social order. On the one hand, there was the impulse toward riot and revolution; on the other, there was tyranny and violent control of the poor. It was not only the masses who were in peril; the lenders and owners were in danger of losing both holdings and legitimacy. With some similarity to the current inequity in wealth and ownership in the United States, the polity was on the point of being torn apart and descending into chaotic tyranny. Desperate, the controlling elements called upon Solon, a creditor and landowner, to save the community from destroying itself.

Solon's solution was daring and demanding. He engineered reforms that would cancel much of the debt burden from which he himself benefitted. He got commitment that his plan would be kept in place for ten years without mitigation so that its effects could take root in custom and habit. He chose to go into voluntary exile so that neither he nor the polity would give in to the temptations of dictatorship. Exile was a much greater sacrifice in the ancient world than in our modern one where travel, comfort, and connectivity are easy.

Joyce shared some of Solon's vision. Having a larger purpose that serves the whole society, not just one sector, is critical to good legislation. This means rising above petty or immediate gains for long-term benefit. It means caring for essentials that really need care, not working for unfair advantages for one class of society at the cost of another. Vision is informed by listening across the spectrum. Solon listened to the hungry and indebted as well as his own stratum of wealthy landowners.

Again and again, those who worked for or with Joyce acknowl-

edge what a careful and determined listener she was: colleagues in the House and, later, the Senate; lobbyists, aides, and legal advisors; business and union representatives. Even her children, who faced her strong-willed determination and control in the family crucible, acknowledge that she was and is a good listener. They may not have always liked her decisions, but they always felt heard. She could chew the fat with good old boys from Eastern and Southern Oregon, learn from urban corporations and lawyers, hear the voices of housewives in her districts, and share the personal problems of her coworkers.

For Joyce, perhaps the most difficult reevaluation is divorce. A relationship changes over time, and a marriage that begins with exploration and revelation can tear apart under the pressures of child-rearing and personal aspirations. This is hardly news. But facing the decision is difficult. One cannot learn from mistakes without acknowledging them. As Joyce became more engaged in political issues and dedicated to the time needed in Salem, her relationship with Stanley became rancorous.

A large gathering to mark the beginning of a new legislative session showed the strain. Everyone brought a guest, and naturally, Joyce brought Stanley. A colleague notes, "He was just being a total ass about the whole thing. He was just surly and unfriendly." She continues with the observation that she thought he never supported or accepted that serving in the legislature was what Joyce wanted to do. This attitude also partly rubbed off on the children.

Stanley's resentment over her professional life finally bubbled over. At one dinner party with friends, a bored Stanley hissed – rather too loudly – "Let's go, asshole." Joyce ignored him. A while later, he repeated his demand more loudly. The whole party was embarrassed by the boorish behavior. When they finally left, Stanley mumbled, "It has been a pleasure," to the mother of the host. This older woman, a gracious Southern lady who was extremely polite and proper, acidly replied, "I wish I could say the same."

It doesn't take much imagination to recognize a relationship

that either needs to end or needs to be reborn. Joyce, already involved emotionally with her second husband-to-be, chose the former. She and Stanley got divorced. Once Joyce moved out, she never spent another night at the house. Meanwhile, her political career further grew.

CHAPTER 7
Senate Issues
and Honors

After two terms as a representative, Joyce ran for the Oregon Senate in 1983. There are thirty Senate districts and sixty House districts, with each Senate seat covering two House areas. Unlike the US Congress, the roles of the two state legislative bodies are generally the same; the only significant difference is that bills that raise revenue must begin in the House.

Senate seats are more powerful than House seats because they represent a greater number and a wider variety of constituents. Since there are fewer senators, each one has a stronger voice than a representative. As these four-year Senate terms cover wider districts, they require more campaigning. Joyce won the election with relative ease, allowing her to move into a more powerful position in the Senate. Here, once again, she came to head the Judiciary Committee.

In 1984, after her divorce from Stanley, Joyce married Fred Hansen. The two had met in 1979 when Hansen, who was testifying as an officer of the state treasury, attended a Judiciary Committee meeting. Joyce began hanging out with Fred around the capital as her marriage to Stanley languished and headed for divorce. They shared a commitment to public service and held allied views on the environment; both

were passionately dedicated to their work. With her children grown, Joyce could participate in a more fluid and supportive relationship than before.

Hansen served as the deputy state treasurer before becoming the director of the Oregon Department of Environmental Quality (DEQ). Later, he worked in Washington, DC, for the EPA, where Joyce would frequently join him. After retiring from that position, for many years he was the head of TriMet, Portland's transportation agency.

When Joyce and Fred got married, a friend and volunteer in Joyce's campaign hosted a reception for them at her mother's house in Northwest Portland. Jane Cease, her friend from the Oregon House, was going to be late because Cease's brother had died of AIDS just days before. Joyce told her not to worry; she would have the reception start later in the day, when it was more convenient for Cease. That was the kind of thoughtful care Joyce's friends knew – a commitment to not only her constituents but her friends and colleagues.

Joyce continued an active life outside of her political work. Every summer, she returned to the South Dakota farm to both work and vacation. She visited the hazelnut farm and supervised work there. It was important to her that Aaron and Julia tasted the discipline and expanse of rural life. While her children weren't raised with the necessity of shoveling grain, gathering eggs, or milking cows, at least they would know the slow morning dawn and the returning peace of dusk as humans and animals settled down for the night.

When her children were young, she took them down to the creek to watch fish flashing through the shallows. Holding their hands, she wove along tree-lined shores, posing and answering questions about the natural world. It remains one of her most important principles: children need to go out into and explore nature, to pay attention to the wonders of water, sky, animals, and growing plants.

Joyce and Fred kept a house in Portland and bought another house on the Coast in the city of Oceanside. Joyce also shared lodging in Salem with a group of other female legislators. Fred and Joyce's

work lives were distinct and busy, but they made time to be together. One activity they did together was running marathons; they competed in a race in Vancouver, British Columbia, and another in New York City. "It was grueling," Hansen recalls. Most of the time, they ran together but could get separated by the other runners. Joyce knew how to master the ache of thigh and calf from her farm work. Whether in exercise or her legislative work, "she was absolutely disciplined," Hansen says. Naturally, this discipline in her personal life was the same as it was in the legislature.

By 1985, the legislature had formed a task group, the Criminal Justice Council, to study and make recommendations on criminal sentencing guidelines. This project had wide-term implications, including the ability to plan for needed prison capacity, standardize judicial response, and project the economic impact of decisions. According to Kathryn Nichols, a legislative analyst, Joyce had a profound impact on the work. She had "a great gift...for understanding complexity of a policy and then selling its merits in simple ways that were compelling."

This quality came partly from Joyce's work ethic and scientific background. She was able to get down into the fine points but not get lost in the data. She understood the particulars without ever twisting or distorting the facts. How different this can seem from current legislative practice where legislation is too often shaped by ideological preoccupations and information provided by lobbyists! For instance, Joyce made it a practice to visit a women's prison and talk with the inmates. She found it necessary to grasp the implications of her work from those it might most affect. She was a whirlwind of practice, once she had latched on to a purpose.

The work was difficult and prone to disagreement. Joyce says, "The Judiciary committee tackled controversial issues like abortion. I thought that I needed to get the committee to a point where we trusted each other and treated each other with civility and respect.

You need that to handle difficult issues. Because we really did care about each other, we were able to pass important bills like a major

corrections package, a very strong anti-crime bill, reformed sentencing guidelines, and clarification about the use of prisons."

Similarly, trust helped the council propose a sentencing matrix to regularize and guide judicial decisions. One axis was the severity of the crime (for example, if person to person, the severity was high; if a property crime, it was lower), and the other was the criminal history of the convicted. The legislative work enabled executive and judicial branches to more coherently plan for spending. This work became a leading initiative in the nation.

However, establishing policy, no matter how good an idea, also requires getting it approved. Here, too, Joyce was a master. Nichols notes that Joyce was "politically savvy in a way I didn't then understand as a young analyst." Nichols goes on to say how much she has come to appreciate Joyce's sophistication and mastery of legislative action. Staffers in neighboring offices note that they always knew when Joyce was at work; the conversations in the room could be loud and demonstrative or filled with laughter, but something was always going on when she was there.

Joyce's work in the Senate was intense. Over the years, she was assigned to more committees than any other state senator. She served on committees dealing with the environment, energy policy, housing, banking, health, agriculture, and natural resources. She chaired the Judiciary Committee, as in the House, and was the first woman to do so. She also headed the Trade and Economic Development Committee. Her relationship with John Kitzhaber that had been forged in Salem became stronger when he became president of the Senate. Over her three terms, she contributed significantly to tax reform, child abuse prevention, and elder abuse prevention and protection.

Even outside her legislative work, Joyce volunteered for local schools and worked with the United Way and the League of Woman Voters. She was a board member of Specialized Housing, Inc., a non-profit organization providing housing for Oregonians with disabilities, and the Parrot Creek Ranch, a residential treatment facility for delin-

quent youth. Without extraordinary focus, all these involvements – and there were many more – would have led to a scattered and diminished leader.

Joyce was honored by many interest groups, including the ACLU, the Oregon Library Association, and the Oregon Community College Association. She was chosen as a Woodrow Wilson Fellow to lecture on public service and policy development throughout the nation on college campuses. Over the years, she worked with six governors (Straub, Atiyeh, Goldschmidt, Roberts, Kitzhaber, and Kulongoski) and knew most of the state politicians, from US senators to city council members throughout Oregon. She is particularly appreciative of Vic Atiyeh, who helped her despite being from the other party, a relationship more and more unusual. Her partnership with Kitzhaber lasted and is a source of fond memories for both.

Despite her overwhelming workload, Joyce remained focused on the constituents. She remembers, "I had weekly coffees at different places throughout the district. I brought in experts on whatever issues really interested people. I wanted to give my constituents information helpful to them."

During her first term in the Senate, she worked to protect abortion providers. On another culturally sensitive topic, she opposed changing the state constitution to make child pornography illegal. This was not because she was against criminalizing it but because she viewed the solution as legislative rather than constitutional. This choice, however, provided an opening for conservative politicians to run against her. She won handily in her first election, but in the second race, she faced a well-financed conservative opponent, Bob Tiernan. The district had a slight advantage in Republican registration over Democrats (45 to 43 percent.) Nevertheless, she won by 7 percent, 20,760 votes to 17,794, in 1986.

Tiernan ran again in 1990. He based his campaign on attacking Joyce as soft on crime and killing legislation that would attack child pornography, nude dancing venues, and drugs. Much of the attack was

based on lies or misrepresentations, which one small-town newspaper, the *Wilsonville Spokesman*, wrote about: "Tiernan should be ashamed of himself for these gutter techniques. Cohen should be applauded for having the good sense not to crawl into the muck with him."

Every other major newspaper in her district endorsed her over Tiernan:

Two-term Sen. Joyce Cohen, D-Lake Oswego, is the most effective senator in Salem, period. She is smart, aggressive, effective, diligent, and dependable. The 1989 Legislature enacted the toughest anti-crime package in 10 years [a hot topic at the time]. As chairman of Senate Judiciary, Cohen deserves much of the credit for that...her influence and reach in the state Senate is simply beyond Tiernan's wildest dreams (The Oregonian,10/25/90).

She was the only state senator who received a rating of "outstanding" in Willamette Week's biennial poll... Cohen has also received raves from environmentalists (Willamette Week, 10/25-31/90).

Cohen took a lot of heat as the "bill-killer," stopping bills that would have banned nude dancing and changed the punishments for child pornography. Both would have meant constitutional amendments, but Cohen thought the issues could be– and should be–handled by ordinances and laws, not fiddling with the constitution (West Linn Tidings, 10/16/90).

Perhaps most impressive has been Cohen's effort to change the shape of Oregon's work force, including investing in literacy training: money for vocational training; creation of the new Oregon Institute of Technology branch of Clackamas Community College Small Business office; and money to let high schools invest in vocational education equipment (Lake Oswego Review, 10/18/90).

Still, it was a tight race. One of her volunteers remembers how focused and serious Joyce was. The volunteer's gift was bringing humor to their meeting. Laughing with Joyce, even over silly things, was one of her contributions in the midst of conflict.

Another one of her campaign managers recalls going door-to-door with Joyce in a hilly part of Lake Oswego. Even after Joyce's full day at the office, he found it hard to keep up with her pace. This canvassing was impressive both for the energy and for the connection she had with older voters. Joyce won, but the need for fundraising and campaigning was beginning to diminish her appetite for future races.

Her campaign literature emphasized three themes under the headings "Joyce Stays in Touch," "You Know Where Joyce Stands," and "Joyce Gets Results." As a politician, her connection with her constituents was always one of her strongpoints. Her commitment to listening was genuine, and she pursued it assiduously in community meetings, phone calls, questionnaires, door-to-door greetings, and helping others cut red tape quickly to solve problems that involved the government.

Unlike the hypocrisy and prevarication that currently fills the internet and airwaves, Joyce was transparent in her positions. This honesty was an innate characteristic. It also helped her stay independent of special interests by "taking stands and sticking to them," as her campaign pamphlet attested. She listed six areas where she made her positions clear: environmental protection, education, women's choice, crime, health care, and taxing. Her top priority was stable and equitable financing for schools without raising taxes. She was unabashedly pro-choice. She helped pioneer a plan to make health insurance available to children and to Oregonians who could not afford private insurance.

She talked on the campaign trail about getting results and how her leadership ensured lottery money included funding for job-training programs in high schools and community colleges. She also highlighted a bill of rights for nursing home residents, the funding of essential utility services at reasonable cost for seniors, and replenishing the War

Veterans Loan Fund to help veterans with home ownership. She noted her efforts for local communities in her district, such as the End of the Oregon Trail interpretive center and the Lake Oswego Trolley.

Purpose, focus, and practice aptly describe what Hansen calls "her absolute discipline" when pursuing an objective. He tells the story, confirmed by Joyce, of a time in Governor Goldschmidt's office when she was opposing his desire to move a shipping terminal from Portland to the Coast. Goldschmidt called her to his office and put on funny glasses with feathers sticking out to distract her. This had worked with other female lawmakers, making them laugh and turn away from their purpose. Joyce saw right through the diversion and refused to be distracted.

CHAPTER 8
The Smiling Barracuda

Sometimes good listeners are not also good talkers, but Joyce is both. In conversation, she is direct and even blunt but without ill humor. In controversial situations, she has done the thinking behind the scenes, which leads to clarity and force in expression. She was never afraid of contradiction or vigorous discussion, acknowledging that the way forward may be better or at least more possible because of passionate talk. One person who worked with Joyce as a legislator states that a discussion with Joyce can feel like an argument, but it is not. It is just forceful and direct. When asked about Joyce's style, she responds with one word: "Whew!" Joyce's son also relates how direct Joyce is in conversation; you always know where she stands, but you never feel diminished even if you cannot prevail.

Another part of Joyce's practice was keeping relationships even when there were policy disagreements. As noted before, she became lifelong friends with Roger Martin, the conservative Republican who had defeated her in her first race. From her early days in the House, Joyce reached across the aisle. Vic Atiyeh, a Republican who had served in the House and then the Senate before becoming governor, mentored her when she started to serve. She remained grateful for his guidance and collaborated with him on mitigating some of Oregon's serious revenue shortfalls. She valued the relationship with him

even though they had differing political views and disagreed about a lot of legislation. These mutually supportive interactions are currently disdained by the ideological purists of such movements as the Tea Party, Freedom Caucus, or similar groups from the right wing or the left wing. However, Joyce believes the attitude of no compromise is antithetical to the practice of politics. While it captures purpose and extreme focus, it undercuts any practice by eliminating actions.

More than anything else, her colleagues and friends valued her listening skills and the advice that grew out of them. When Joyce's close collaborator Jane Cease faced the difficult decision of whether to run for office again, she shared her predicament with Joyce. Redistricting had changed the boundaries of Cease's territory so that it was much less politically friendly. She also would be running against another female legislator, which felt at first like a betrayal of sisterhood. Later, she realized that women running against each other was a mark of progress. The essential determining factor to run again was Joyce's listening and concern. She mitigated Cease's fears and helped her see a path toward continuing her political career; she took Joyce's counsel and persevered. Cease doubts she would have had the endurance without that support.

As someone who has dealt with varieties of misogyny all her life, Joyce was and is a strong advocate for and friend of young women. She feels that women need to be uppity to combat the traditions of the old-boy networks that dominate many professions. A staffer fondly remembers when she was considering leaving public service analysis for the private sector. Joyce took her aside and convinced her not to, telling her that she wouldn't be happy "making widgets." The woman has been delighted that Joyce's words gave her the strength to stay in public service.

Although a workaholic who paid the price in her family life, Joyce enjoyed parties and hanging out with her colleagues. She found a way to have fun in and around work. She and her five female lawmaker housemates in Salem, four Democrats and one Republican,

called themselves the Queen Bees – partly in response to a male cadre called the Hornets. The house was a center for planning, sharing, and forwarding women's issues. In the evenings they sat on the rug in front of the fireplace and supported each other. A member could discuss the details of a bill from a committee that she was on. This could mean lobbying each other or, more often, simply sharing information and getting insight from each other.

The greatest example of listening and clarity in thinking (seeing the big picture) occurred with John Kitzhaber. When Kitzhaber was president of the Senate (a position of real power in Oregon), he was faced with outrage and condemnation. The new Oregon Health Plan provided government funding for the indigent. However, as always, resources were limited. The issue came to a head with a child named Coby Howard, a seven-year-old with acute lymphoblastic leukemia. In 1986–87, his case became national news. He became eligible for a bone marrow transplant, although the probability of it helping varied between 20 and 50 percent. An article in the *Los Angeles Times* stated:

> Until recently, the state would have paid for the operation through the Medicaid program. But in July of this year, Oregon ruled that it would no longer finance costly bone marrow, pancreas, heart or liver transplants. At the time, these procedures were highly experimental and had little prospect of succeeding. The state continued to pay for cornea and kidney transplants, which were less expensive and had a high rate of success ("A Transplant for Coby: Oregon Boy's Death Stirs Debate Over State Decision Not to Pay for High-Risk Transplants" Los Angeles Times, December 28, 1987).

What ensued was painful. Family and friends worked hard to raise enough money for the transplant using garages sales or paper drives – anything to garner the $70,000 needed for the operation. Unfortunately, Coby's bone marrow began to show a recurrence of leuke-

mia, so the operation had to be postponed until it was under control. The delay was lethal, and the boy died in his mother's arms at a Portland hospital.

Coby's story had attracted national attention because of the intensely emotional debate over providing care through Medicaid for transplants that were both expensive and risky. Here was the struggle for a young life up against the limited budgets, questionable effectiveness, and program priorities meant to serve large numbers. There were no comfortable answers. Kitzhaber was one of the primary shapers and promoters of the Oregon Health Plan. In his work as an emergency room doctor, he had seen the immense need for state-supported health care. At the same time, the Oregon Health Plan could not support every possible treatment. Kitzhaber became the object of national invective and scorn, even being labeled "Dr. Death" on national television. The emotional support for Howard's struggle was intensive – a winsome child struggling for his life. How could payment for treatment be restricted?

The questions revolving around limited resources and rationing are complex. They involve not only public and private insurance and state budget resources but also how to differentiate and prioritize health needs. These decisions, often made on a case-by-case basis, often based on emotional and clouded thinking, will be made, with or without policy. But faced with the storm of outraged sympathy for the boy, Kitzhaber wavered.

As in her work on criminal justice, Joyce was a bulldog in mastering the details of this issue. She understood getting down to the actual costs and resources in public health spending and again helped to create a matrix that could make the choices as clear and fair as possible. Colleague after colleague has noted her focus on details without losing connection to the big picture.

Kitzhaber credits Joyce with putting this problem in clear focus. Since rationing of medical resources was an obvious necessity (not every treatment in every situation can be covered), it made sense to

prioritize the most needed, likely, and effective conditions for relief. The greatest good for the greatest number must be part of the plan, and the rare, hugely costly, or experimental treatment for a few select patients cannot jeopardize care planning.

According to Kitzhaber, Joyce had a simple insight. If you had the next dollar to spend, would you spend it for one exceptional case or on thousands of equally deserving and more common ailments? One-on-one, we would choose our loved one to have every reasonable chance even if it were small. But in allocating Oregon Health Plan dollars, no matter how sympathetic a situation was, there must be a limit to what was covered. Her clarity was the vital element that helped him bear up to the extreme national and local opprobrium. Underneath are the basic principles, Joyce stresses: do the detailed work (practice) but focus on the big picture (purpose).

On a more humorous note, Kitzhaber and Joyce share an odd story of medical camaraderie. Some years after the Oregon Health Plan issue, Joyce was mildly troubled by a cyst on her arm. While on a break from a Judiciary Committee meeting that she was chairing, Joyce went to Kitzhaber's office and happened to mention the cyst. Jane Cease was there too. Kitzhaber kept a medical kit in his cabinet; colleagues occasionally asked him for some benign service. He offered to remove the cyst right there in the office. He got out a syringe of anesthetic and a scalpel and took care of the growth. Joyce, normally stoic is such situations, fainted. When she came to, she had a shot of Southern Comfort with the other two. Then, as if it were the most ordinary thing in the world, immediately went back to work chairing the committee.

Her stamina was well-known. She could work full speed for hour after hour, pausing only for a ten-minute nap on the floor behind her desk. Then she would be back at work.

Joyce was both the first woman and the first non-lawyer to chair the Senate Judiciary Committee. She had earned such a reputation for clear and logical thinking that she was appointed to it. As in her House days, she took to increasing her legal knowledge. On top of

the normal fatigue of being a serious legislator, she always took on the chore of learning more after hours. The pile of books and documents she brought to committee meetings could intimidate colleagues, opponents, lobbyists, or those testifying. Holding up her hand so that she could check on some matter in question, she could make precise inquiries. Here was one more example of practice: doing the work and overcoming obstacles.

Similarly, on the banking committee that she chaired, Joyce did her homework. She spent the hours to learn the terms and issues, not taking shortcuts or relying on privilege or secondhand synthesis from aides. This made her a formidable senator. A *Willamette Week* article noted how much more she understood the intricacies of banking policy than any other committee member. One lobbyist suggested that she knew more than the lobbyists themselves. When high-powered, elite Eastern bankers came to testify, Joyce was more than prepared.

The large, well-funded lobbying campaign was aimed against Cohen over SB 357. This bill was to allow out-of-state banks to buy troubled Oregon banks. One company that fought the bill furiously was the U.S. National Bank.

After weeks of consideration, the U.S. Bank sent their chief executive officer to testify at a televised and packed committee meeting. Apparently, the intention was to overwhelm the home-grown lawmakers. He gave an arrogant, hostile, and insulting testimony. Joyce just took him apart in her questioning and made it clear how inept and unsupportable the bank's position was.

One lobbyist and friend who worked on several of her reelection campaigns relates how intimidated people could be by Joyce. On numerous times, those who did not know Joyce would ask for introductions. Sometimes, they would even seek to have the lobbyist go with them when they met Joyce. Yes, she could be overwhelmingly direct and to the point, but she could be quite charming. More than once she used her country-girl wiles to set up Eastern Oregon (read: rural) legislators by bringing them coffee and doughnuts while soft-soaping

them. A couple of times, when she knew a committee vote was coming up for which she had the votes but that would be difficult for the Easterners to justify, she sent them on an errand so that they could claim that they had no responsibility for the vote.

Joyce earned the sobriquet "the smiling barracuda," a nickname of which she is justly proud. Yet she remained friends with political opponents and did not let bruising political fights become personal. Even with allies, when they disagreed vehemently on a procedure, she could be tough and persistent, though never unyielding if better reasoning or political necessity was stronger. However, most of the time, she was more prepared, more persistent, and more thoroughly thoughtful than those on the other side.

Bill Bradbury, who became Oregon Senate president and later ran for US Senate, was a longtime collaborator. "Joyce was decisive," Bradbury says. "You knew where she stood, and she was rock firm without being abrasive." This style naturally created animosity from those who could not get around her. Former husband Fred Hansen says one of her greatest strengths – refusing to easily compromise – was also one of her weaknesses. Some people disliked her forcefulness. She would foresee the bottom line of issues and focus her work toward those achievable ends. She was always a hard worker. At the same time, she was delightful. Colleagues would gather for evenings of Chinese food, stories, shoptalk, and laughter, and Joyce was a regular participant. (In the early nineties, it was still common for Democrats and Republicans to get together as colleagues.)

While her style could be brash or brusque, it was ultimately empathetic. A few lobbyists or commentators found her abrasive but most colleagues over the years expressed unabashed respect and admiration. With Joyce, you knew where you stood and where she stood. There was no resentment under the table. You argued, you maneuvered, you fought bitterly for your position. When the matter was decided, you shook hands and remained friends.

CHAPTER 9
The Lottery and
Final Legislative Years

In 1993, as John Kitzhaber was moving out of the Oregon Senate presidency into the governor's race, Joyce became a candidate for the presidency position. Bill Bradbury was an ardent supporter of Joyce's candidacy; he recognized the value of supporting a woman for top leadership. Joyce would have been the first female president in that chamber's history; however, voting was deadlocked. While she had more backing than a more conservative member, Gratton Kerans, neither had a majority.

The caucus deadlocked for weeks. Finally, Bradbury became the compromise candidate. Since she was unable to win, Joyce gracefully and wholeheartedly gave her support to Bradbury. He always felt that it was a lost opportunity for the Senate and for Oregon. The Senate presidency can be a natural stepping-stone to running for governor; it would have given Joyce much more influence and opened the possibility of higher office. Nevertheless, he accepted the nomination, later becoming the Oregon Secretary of State and a challenger in a primary to Kitzhaber for governor in 2010.

Bradbury worked closely with Joyce on a variety of issues. He has called Joyce "visionary" in her promotion of economic develop-

ment. He notes that she realized before anyone else that the old way of timber management was coming to an end. In 1993, for instance, there were dozens of sawmills along the Southern Coast in places like Coos Bay. By 2019, there was only one.

Production of two-by-fours and plywood was not going to be enough to sustain the industry. A state that had relied on harvesting and sawmills needed to move to value-added activity. International trade had changed how the natural resources economy worked. Joyce had the insight that the timber corporations had to develop new ways in which they could transform their management, products, and services in a technologically rich environment. She supported new products and new trade opportunities along with an unshakeable commitment to sustaining forests for commercial, recreational, and environmental needs.

Coming from a rural part of the state largely dependent on lumbering, Bradbury especially knew his constituents would be facing economic decline. Community college training programs, partnerships with business, and other counseling and job transition programs would help mitigate some of this loss. Before he or anyone else, Joyce recognized the need for these programs and developed legislation to support them.

One example of Joyce's dedication to purpose was in the Oregon State Lottery. This proposal, supported by Kitzhaber and other political allies, was strongly opposed by Joyce. She did not believe the state should be involved in the gambling business or support an activity that would either disadvantage those with the least educational resources to appreciate the minimal odds of winning or encourage those prone to gambling addiction to risk becoming trapped. Kitzhaber, as Senate president, and Governor Goldschmidt were determined to push the state lottery through the legislature. It was the only time that Joyce and Kitzhaber vehemently disagreed.

Joyce could see that the initiative was going to pass and become law, so she turned her attention to how lottery income would

be spent. Instead of being sloshed in with a general fund where legislators and governors could allot the resources as they wished in the short term, she insisted that lottery revenue be strictly dedicated to education, the environment, and job training. With the agreement of the bill's authors, these principles were written into the law, and Kitzhaber backed her up in this process. Joyce guided the lottery money not only for education and health initiatives but also for the planning, incentives, and development of physical resources and intellectual ones. Joyce emphasizes that one can always – always! – turn a circumstance or decision that one opposes in a direction that has positive benefits.

Bradbury considers Joyce's work regarding state lottery money to be one of her greatest contributions to the state. As of 2018, over $3 billion have been generated for job creation and economic growth. While the majority of the income goes to prizes, about one-fifth goes to programs like public education (about 53 percent of that fraction), job creation (26 percent), watershed improvement and salmon restoration (7.5 percent), and smaller amounts to veteran affairs, outdoor school, and other items.

Joyce stayed involved with projects and interests over decades, both small and large. One colleague remembers how she championed a woman who was disabled and having trouble getting the assistance she needed. Joyce took the time to become personally involved in helping rectify the situation – an act characteristic of who Joyce is.

Her involvement with the Oregon Trail and Oregon City began in the early 1970s and continued through her legislative career. She long worked for revising the master plan to offer access to Willamette Falls in Oregon City. Even from her assisted-living facility, she consults with and advises the director of the End of the Oregon Trail interpretive center, Gail Yazzolino. Kitzhaber, other former colleagues, and journalists continue to visit her for the opportunity to talk through plans. Joyce's insight and advice remain relevant. In 2018, the Oregon State Capitol Foundation (oregoncapitalfoundation.org) began an oral history project for state politicians; Joyce was among the earliest to

have an interview recorded and archived.

PART II LESSONS

In Doris Kearns Goodwin's book, Leadership in Turbulent Times, the author lists qualities of successful leaders. Leading in a collaborative body like a legislature has some different qualities than leadership in an executive position. Here are some of Goodwin's qualities that Joyce reflected:

Gather firsthand information; ask questions.

More than any other of her qualities, this one stood out in Joyce's process. She was always willing to do detailed research. She displayed diligence and comprehensive concern with an issue. She knew that mastering the details while not forgetting the big picture made for better decisions. As when teaching herself the law or the minutia of banking regulation, Joyce had the discipline to be truly informed. Her country background that favored knowledge gained through work more than the cleverness of words enabled her to appreciate the laconic farmers and ranchers of Eastern Oregon. She knew how to listen and how to get to the bottom of issues.

Anticipate contending viewpoints.

In thinking through issues and understanding the details, it would become clear to Joyce what the basis of the objections to a policy were. Once she understood the objections, it became that much easier to convince or override obstacles. She had a gift for understanding the complexity of policy and then selling her view in a way that genuinely addressed the opposition. She was not afraid of contradiction but welcomed a vigorous discussion.

Understand the emotional needs of each member of the team.

Joyce was explicit in helping a team work together. She knew that the way through or around difficult discussions was prepared by building trust and camaraderie in her coworkers. This took place in treating members with respect during sessions and mingling outside of work with those with different viewpoints. Her network of women colleagues gave insight into members of a committee. She was acutely sensitive to what each one needed.

Refuse to let past resentments fester; transcend personal vendettas. Set a standard of mutual respect–control anger.

Joyce practiced remaining lifelong friends with members of the opposite party even when they had bitterly disagreed. Roger Martin, the conservative politician who bested Joyce when she first ran for office, remains her friend. This was also true within her own party. When she lost her bid for president of the Senate or in her battle against the state lottery, she refused to hold a grudge. This allowed her to stay involved in shaping decisions like how lottery money should be spent and provided a dependability both friends and foes could rely on.

Find ways to cope with pressure, maintain balance, and replenish energy.

Joyce's connection with family, physical activity, female friendship, and, especially, nature served as needed counterbalance to her focus and unrelenting practice. The habits formed in childhood and scientific research built a resilience to conflict. Physical activity and periodic recreation in the hazelnut orchard or preparing to run a marathon served to put political work in perspective.

Put ambition for the collective interest above self-interest.
For Joyce, the larger purpose was always paramount. When her quest to become president of the Senate became dangerous to her caucus, she gladly put aside her ambitions in order to support another nominee. She rarely felt that issues were about her but about what could be accomplished. She had wanted to be involved in medicine to serve others, to build transparency in government, to champion Oregon City and, separately, the involvement of Native peoples in environmental choices for the greater good. This was an outstanding quality of several earlier female legislators, such as Norma Paulus and Betty Roberts.

Be accessible and easy to approach.
Although Joyce could be initially off-putting, once anyone crossed the threshold, they found a humorous, convivial partner. She was no-nonsense, but that didn't mean anyone found her unfriendly. She loved laughing, and one staff member recalls that she had a gift for it. She was completely honest and trustworthy so that once you got past the sometimes brusque first impression, it was easy to share whatever you needed. Although she was not easily emotional, those who knew her well could experience the full range of her emotions.

Among the many lessons from Joyce's life, perhaps none is stronger than the idea that you can always turn an obstacle or lost political fight into a positive. Nothing shows that characteristic more clearly than how she conducted the next phase of her life.

PART III
REFLECTION

CHAPTER 10
The Accident

If the first third of Joyce's life was about growth – experience from the immensity and smallness of the South Dakota ranch through scientific training and family – and the second third about politics and legislative purpose, the third part becomes about energy. In each period, a different form of will predominated. Exploration, action, reflection: an archetypal pattern for human life.

The inner growth in the third stage of life is the hardest to document. In youth, the adventures and explorations are easily seen, and in maturity the actions taken in work, artistry, or family are also observable. The development in elder stages of life can be more internal. Reflection, releasing of external concerns, gratitude, and arriving at a new appreciation of the self are primarily experienced by the individual themselves. The initiation of this stage in Joyce's life was abrupt, although she remained strongly involved in her life of action.

In 1993, everything in Joyce's life changed. Yet in many ways, the most essential qualities not only remained but grew stronger. The life Joyce had been leading was active physically, emotionally, and intellectually. She had run marathons in British Columbia and New York City and had plans for one in London. She was still involved with her marriage to Fred Hansen as well as her relationships with her children, their families, and her numerous friends. Her life in the legislative

world was absorbing.

That year, when Joyce was back at the farm that her birth family still worked (her brother Bob ran the spread that ranched cattle, grew hay to feed the stock, and raised wheat and corn on hundreds of acres), Joyce was out for a ride on a black Indian pony. She was an experienced rider who had known horses all her life. What happened next is not entirely clear. Perhaps the horse shied and threw Joyce off, causing her to hit her head, triggering a stroke. More likely, a stroke caused by the AVM she had been living with for so long caused her to fall off the horse. How much time she spent on the ground, unconscious, no one knows. On the ranch, they were sixty miles from a town of any size. Finally, she was found and an ambulance dispatched. She was initially taken to a small hospital in Hedinger, where the bleeding in her brain was not treated. She was then transferred to a larger facility in Bismarck. She lay in a coma for a week.

When she returned to consciousness, Joyce wished to return to Oregon. Not one to linger or feel self-pity, she insisted. Hansen, who had not initially gone out to South Dakota, arranged an airlift for Joyce back to Oregon. There, Joyce was transferred to a rehabilitation center. Hansen tried to make the best of it. He says, "I take things as they are."

It was difficult. Joyce's thinking was scattered at times. She still feels that she sometimes reverts to that state. She was paralyzed on the left side of her body, and her speech was slurred. Her vision was challenged and her thinking confused. At first, the ability to sit up or take care of basic body functions was lost and had to be arduously relearned. Every day, even every hour was a struggle. She now puts it in terms of trying to land a fish – a giant fish that resists with all the strength it can muster. In addition to incapacity was pain. Internally, she would have to rewire her body to function but also not to be crippled by acute pain. For a fiercely self-reliant person, it was daunting to rely on others; that too had to be learned. It presented the amazingly difficult task of re-creating one's entire self without much of the habitual self to rely on.

The next several months in rehabilitation were challenging; the reintegration work would be with her for much, much longer. Joyce says about that time: "I spent a week in a coma. After I came out of it, the doctors urged me to take opioids to reduce the pain. I refused. I knew I could recover some strength if I stayed focused. Opioids could hold me back. I got almost no encouragement from the medical personnel or medical system as I worked on rehabilitation." The pain was unrelenting. Each movement required attention and sometimes caused acute lightning shocks through the nerves. Her refusal of opiates to give relief from the pain was a deliberate choice even though it led to suffering.

Still, her life of practice and purpose was an essential framework. Her determination was intense. Within months and still in rehabilitation, Joyce's active mind told her that she was responsible to get her life back, and that meant returning to her legislative work. Joyce knew there was a new legislative session to attend, and she was absolutely determined to participate, even though it took two years to stand up on her own and take a cup from a cupboard, get coffee, and bring it to a table.

The only thing playing over and over in her head was "practice and focus," "practice and focus." It became a life-giving mantra. Her survival was her own responsibility. Sometimes, though, it was too much. One time when her daughter was taking her to physical therapy, she asked her to stop at a bridge. She wanted to jump off. So much of her body was in intense pain, and even partial recovery was taking too long. She continued in survival mode day after day. Although occasionally she wanted to give up, Joyce remembered that she had a purpose and that she had to work through her challenges herself without relying on the medical system to fix things. It was another echo of the lessons she had learned years earlier on the farm.

To clarify, her perspective did not contradict the access to medical care for all Oregonians that she had championed in the legislature; she believed in working with and through doctors and hospitals, not

working without them. This called for a heightened sense of self-care that integrated science and inner will. Heroism was not just a firefighter engulfed in a hell-storm of devastation or a nurse working around the clock day after day in a pandemic. It was also, in Joyce's case, the bravery to choose the help and advice that met her individual circumstance.

Her physical therapist, Susanne Carlson, wrote about Joyce's efforts in *Who Do I Become When I Am No Longer Me* using a fictional name for Joyce. Carlson remarked how there was no containing the determination that Joyce brought to her rehabilitation. After a short inpatient stay at an intensive care unit, Joyce began outpatient care. Here, the purpose, focus, and practice Joyce had utilized in her legislative career turned toward her healing. While battling near constant pain, she had to continually repeat passive range-of-motion exercises. This meant tediously moving body parts again and again and again. There were water exercises where she needed to be supported by aides or mechanical devices. She would work all day, seven days a week. The therapist sometimes felt that Joyce was denying the reality of her situation but added that this denial was also a strategy that helped her keep going.

Long after she had gotten past the initial struggle, Joyce kept pushing. Carlson noted that Joyce hated her wheelchair, banging her hands when she went around corners because her spatial perception was off. This brought about a new set of challenges and exercises for her eyes. She did not like the braces on her legs any more than the wheelchair.

One day, Hansen came home to find her attempting to walk by herself down a hallway. She was using the wall as support, advancing inchingly on her right side and then dragging the left foot forward. It was exhausting and could have led to a serious fall. Another time she pushed herself too hard in the garden and had to spend the afternoon stuck on the ground because she couldn't get up. A summer later, she decided to help paint the exterior of her beach house. She rigged up a

paint roller using her chest as a support, and, half-paralyzed, climbed a ladder. She used her forehead to reach higher areas despite getting paint all over herself. Carlson found her an ongoing challenge to keep on top of or ahead of what Joyce needed.

Joyce's determination, however, was difficult for more than just her therapist. Unlike other patients who were either more compliant or actively undisciplined, Joyce never stopped doing more than recommended. She constantly pushed against boundaries and beyond what she could do. All of this drive took its toll, and it wasn't pretty. By the end of each day, she was drained, and Hansen was also. Every little movement required time to manage it and accomplish it. If she felt something cold, she had to sort through the sensations: Was this ice? Were her eyes not seeing accurately? Was this in her brain but not on the body?

Yet, with a new legislative session to attend to, she insisted on going to meetings in Salem. Friends transported her and her wheelchair so she could continue working. She may not have loved her wheelchair, but she figured out how to have fun with it – a key strategy in Joyce's survival. Back in the capitol, she had wheelchair races in the halls with Frank Roberts, a Senate colleague who was also in a chair. Joyce wryly notes, "The rehabilitation people did not approve of that when they heard about it."

Many people who had worked with Joyce and had experienced her determination in the legislature witnessed a new level of purpose. One longtime friend and collaborator admired how Joyce was able to redefine her life in the face of all the obstacles. It was a different level of purpose, focus, and practice already evidenced by her previous work. In Joyce, she saw how someone can take charge of their life and direct their energy despite difficult circumstance. It was the kind of courage shown by military heroes, by those facing but not bowing to life-diminishing illness, by parents who overcome the grief of a deceased child, by those willing to speak truth to power and bear the consequences to livelihood or social comfort. When one person acts

with dedication, it lights the way for many to stand upright as well.

It is typical that even in recollection, Joyce emphasizes the positive and, in this case, fun side of things rather than the suffering. Part of accepting purpose is to also invite humor into the vision. Humor leavens focus and practice to keep them from becoming odious. The loaf becomes more buoyant with fun in the mixture.

Eventually, her and Hansen's house became too much to attend to. A wet or icy walkway could be lethal. Stairs were obstacles. Even getting a cup from a cupboard that required reaching could take a quarter of an hour. They bought a condominium in Northwest Portland. The area, now known as the Pearl District, an upscale area of the city, was just on the verge of redevelopment. They got a remarkable deal in a building with an elevator. The loft was nearly a full floor, spacious with high ceilings, a view of the city, and conveniences such as pullout shelves that made living with a disability much less taxing. Outside the bedroom window, hummingbirds built a nest, and every day Joyce could watch them feeding the young and teaching them to fly. She would take more interest in nature as time went by.

Not long after Joyce's accident, Hansen took the job with the EPA as part of the Clinton administration. Inevitably, it introduced a significant separation in the marriage. Hansen was busy in Washington, DC; Joyce was busy in Salem and still learning how to navigate her body. However, she took trips to Washington to visit him. Naturally, this travel included all sorts of obstacles. The Americans Disability Act (ADA) had been passed, but it would take years before facilities became more uniformly accessible. A wheelchair without ramps was almost a hindrance. Doors that were difficult to open or swung the wrong way, handles awkwardly placed, restrooms lacking stalls that were wide enough or had no security bars made travel difficult.

Living with a person recovering from such a difficult loss of function can itself be exhausting. No matter how much love and goodwill there is, the constant demand and needs can wear down the caretaker even of someone as determined as Joyce. Perhaps more so.

A longtime friend of Joyce and Hansen explains the challenges. Suppose you were making a pot of soup for Joyce. How and where you opened the can, which pot and burner on the stove you chose, which spoon you got out to stir were all distressing for Joyce. It wasn't that she was contentious or fussy about how common actions were done. She wasn't angry with the help but frustrated with the actions not mirroring what she had to do to achieve the same thing; there was a disjunction between the inner and the outer. To accomplish anything, she had to do it with a conscious process that everyone else could do automatically.

Though this obstacle slowly eased, it never quite disappeared. Later, when Joyce was experiencing carpel-tunnel problems with her good hand, her friend came to visit. She found that the reprogramming continued. Any variation was experienced by Joyce as an upsetting interruption. Things were done in a certain way that made sense to her internal patterns; it was like a chef who wanted his onions hand-grated even if a food processor produced an identical result. A variation in the outer physical world of doing things represented an unconscious existential challenge to how she needed to proceed.

More often than not, these dissensions could lead to humor. Joyce was lugging heavy flowerpots to the sink to water them one day. Not only was this difficult, it aggravated the carpel-tunnel condition. Her friend suggested that she get a rolling cart. Joyce did not want a cart. The friend kept nudging. Joyce kept resisting. Finally, one night her friend just went out and bought one. "I knew you were going to do that," Joyce said. It wasn't long before Joyce was using the cart for many things and laughing about her stubbornness in refusing to get it. Years later, they still laugh when talking on the phone, Joyce reminding her, "I'm using the cart again."

As the 1993 legislative session wound to a close, Joyce needed to decide about running again in 1994. She had failed to become president of the Senate. Her husband was across the country much of the time, and there was her paralysis to deal with. As one of her campaign

volunteers noted, Joyce loved the work of campaigning, going door-to-door, and meeting voters. Now that would be nearly impossible. Added to that was the changing nature of politics that had begun to harden into the hyper-partisanship so typical of the twenty-first century. She had already gotten a taste of that in her last race, against Tiernan.

Plus, the cost of campaigning now required raising significant amounts of money that had nothing to do with meeting constituents and trying to serve them. The dominance of money in politics seemed to increase with each year until appalling amounts were necessary for even minor offices. With all those impediments, Joyce decided not to run for office again. Her time was more valuable in other ways than raising money.

In 1994, Governor Kitzhaber appointed her to the Northwest Power and Conservation Council. This council was established in 1980 to coordinate and oversee the regional activities for Washington, Oregon, Idaho, and Montana in regard to forecasting and providing for future energy needs as well as maintaining healthy ecosystems. According to the council's history, as quoted on the Northwest Power Council website:

> Perhaps the most critical factor to passing the Act was the region's disastrous decision to build five nuclear power plants in the state of Washington in the 1970s. Utilities based their decision in part on inaccurate Northwest electricity load forecasts. Only one of the plants, the currently operating Columbia Generating station, was ever completed. Due to exorbitant cost overruns, utilities abandoned or mothballed the other four plants prior to completion.
>
> Two of the unfinished plants were responsible for one of the largest bond defaults in the history of the nation, while the Bonneville Power Administration backed the financing for the other three plants. Even today, more than thirty years after Congress enacted the Northwest Power Act, BPA pays millions of

dollars a year on debt service... Energy efficiency would be the priority energy resource for meeting the regions' future load growth, a visionary decision even by today's standards [and need for clean energy]. For the first time in history, energy efficiency was deemed a legitimate source of energy... The Council's fish and wildlife program is part of its power plan to ensure that the region meets its energy needs, but not at the expense of our natural resources (Northwest Power and Conservation Council, www.nwcouncil.org).

From her earliest involvement opposing the Trojan Nuclear Power Plant to its closing in 1993 when she was chair of the committee that required its closure, Joyce had been profoundly involved with the purposes of the organization. Serving on the council meant the difficult job of balancing power generation with protecting fish as well as the competing interests of four state governments, farmers, consumers, and conservationists. With two representatives from each state on the council, the body exerted considerable power over utilities and local government. It also coordinated with the needs of the Native American nations in the Columbia River Basin and neighboring Canadian provinces. Every five years, contributors from the four states reviewed and modified the plans. Having been involved in these matters for twenty years, Joyce became an important member of the council.

All of Joyce's previous legislative work remained part of her life. She still met and advised all sorts of legislators and continued her involvement with Oregon City, the ACLU, and the environmental movement as well as serving on the Northwest Power Council. An earlier chapter of her life concluded when her former husband, Stanley, died in a tractor accident on the hazelnut farm in 1995. They had had little contact for many years, and his passing relegated that relationship to a distant memory. Now, new chapters unfolded along with reconnection with old interests.

CHAPTER 11
Regaining Purpose

Joyce's son, Aaron, then in his thirties, and her daughter, Julia, late twenties, were an important part of her care. The stroke she'd had felt to them especially disconcerting because it didn't fit the pattern they had seen while growing up – she had always seemed so healthy. Julia, who lived in the Portland area, was especially vital in getting Joyce to appointments and arranging care while Aaron took charge of her finances and her granddaughter, Scout, looked after the condo.

Joyce had always been very involved with her grandchildren – Marcus, Micah, Maureen, Scout, and especially Sullivan, born late in 1997, who lived nearby in Portland. When he was little, she took care of him several days a week while Julia's older daughter, Scout, was at school.

Scout remembers gardening with her grandmother, going to the beach, and attending movies. She particularly values how Joyce would commit to activity or movies that the kids wanted rather than her own agenda. Of course, there were museums, reading, and exposure to "high" culture, but Joyce was always willing to have fun going along with the kids.

Sullivan remembers how slowly they would have to meet the world, whether going on walks in the city from Chinatown to the Art Museum, doing chores, exploring the natural world at Tryon Creek, or trying on an unplanned adventure. Going slowly taught him patience

and attention to each moment. Unlike her time with Aaron and Julia, when she was also deeply involved with legislation, Joyce learned to focus entirely on nurturing her grandchildren.

As a teenager, Sullivan stopped by once or twice a week to help with chores that were easy for him – like changing a light bulb – but arduous for Joyce. He remembers her as an awful copilot when he learned to drive because of her penchant for going a certain way even when he knew a better way. "No, no, no, turn back there," she would say. Her stubbornness was both a gift and a curse. One time she wanted to send three packets of soup to her granddaughter Maureen in Edinburgh, Scotland, and gave Sullivan her credit card. He returned without sending the soup because it would have cost eighty-one dollars. Joyce insisted that he return to the post office and mail the soup despite the cost, though he privately thought Maureen would have preferred the money over three packets of soup.

Joyce encouraged all her grandchildren to "reach high and don't settle." She also provided financial help to each of them. Sullivan was able to take an unpaid research internship that was critical to his development as a scientist because she paid his living expenses. Despite the occasional challenges, he values the lessons he has learned from her. She inspired him with her incredible resilience, her intelligence, and her creative ability to work around challenges. In addition to the patience he learned as a young child, he gained a great appreciation for her spiritual connection with nature.

As her grandchildren grew, Joyce traveled with them, advised them, and took an active role in encouraging their educational pursuits. She had high expectations and standards mixed with appreciation for their differences. It was important that each felt empowered with what they could do and, given her own medical research background, that the grandchildren had a strong connection with science. Joyce modeled being proactive in facing obstacles and being thick-skinned. She was not romantic about nature and would tease family members for their cutesy involvement with cats like giving them

names and endowing them with personalities. Each individual child was a focus for Joyce rather than lumping them together as the grandchildren.

As Joyce's attention turned toward her grandchildren while remaining with her political connections, her marriage to Hansen came to an end in 2004. It was a surprise to Joyce, but their lives had been moving in different directions. A friend recalls getting the phone call from Joyce. She was in a hotel room with Hansen and he had just asked for a divorce. Joyce was in shock. Hansen, perhaps worn down by the necessary care and engaged with a demanding career of his own, realized they needed to go their separate ways. The split was not contentious, and Hansen made sure that there were adequate resources for Joyce. Joyce remained in the loft. The separation and ensuing divorce were amicable.

Her connection to health issues in public policy remained as strong as before her stroke. In some ways, her condition reinforced her commitment to the central part health issues play in everyone's life. It also emphasized her own responsibility for self-care. This had been implicit before the accident but became a key part of her thinking. It both sharpened her confrontation with standard medicine practice and made more conscious the internal work she had been doing.

With regard to the former, she relates a story, part medical drama and part comedy: She was visiting the OHSU campus. Once again, the hospital doctors wanted to force her to take blood pressure medicine to cover themselves for insurance purposes. She refused. The doctors and nurses insisted. Eventually a security guard was called because of the heat of the argument. After more than an hour, Joyce stood up to go, but another guard was called, and they took her down to the emergency area, expecting her to have another stroke on the spot. The arguing continued, and after a couple of hours, Joyce insisted that she needed to go to a meeting in Oregon City. Finally, the staff gave up and said goodbye.

That was not the end of it. She told one of the guards, "You

need to take me to my car. I'm not going to try to walk around this immense building." In the end, she had a personal escort in a police car around the campus. In the meantime, she was thinking, "OHSU, I'm done with you." The liability concerns of the insurance industry were a negative influence on her care.

In terms of the inner exploration, she explains the work she has to do on a daily basis: "I'm paralyzed on the left side, but I still need the energies on the right side of my brain [which controls the left side of the body]. My whole right side has to move all the liquid out of the left, so my brain has to work in a different way. Nobody in the medical system understands what it means to make it work in a different way." Joyce finds that a doctor's technical or mechanical understanding of a patient's physical system, along with a frequent lack of warmth in standardized, industrial medicine, does not meet a patient's full humanity. Often, one has to advocate to be fully included in one's treatment.

This has led to a determination to find other methods of healing that lines up with her inner experience. For instance, traditional Chinese medicine views the health of the body in a very different way from Western medicine. This did not mean Joyce fell into antiscientific nostrums or magical thinking but weighs information and is active in choosing treatment. She makes it clear that her resistance to blood pressure medication is because of the effects it has on her; other people have other needs, and this medication may be vital to them. Each body is different from statistical norms.

The keys to learning in more depth how to use her body were constant focus and practice. In the physical sense, this was obvious – using a wheelchair, walker, or cane and understanding how to limit herself to what she could do. Setting limits for herself was not in her nature, as made clear by her challenges with her physical therapist. Going forward required a new level of deep attention to her body.

First, naturally, was how to avoid acute pain. In order to do what she was determined to do, she had to create new strategies of

movement. As with any new skill, this required experiment and patience. Much of the learning was internal and not observable from the outside. For example, she discovered how to fall without getting hurt.

The second learning was even harder to conceptualize. It meant discovering how energy flows in the body and how to use that energy. Circulation of lymph and other fluids and using the breath to achieve these purposes had to be guided by both intuition and whatever she could glean from outside sources. Much of it required subtle attention to sensations and pathways that are normally below consciousness.

Joyce had long been interested in cultures and philosophies outside of the traditional Western canon. When a longtime friend of hers became involved with Qigong in Seattle and invited her to a workshop with Qigong master Mingtong Gu, naturally curious, Joyce decided this might offer a different way to do her internal work.

Qigong is a diverse set of practices under a single title, much the way yoga can refer to a wide variety of physical, mental, and emotional paths. Its roots are in ancient Chinese traditions and have developed in many ways over the centuries. One loose translation of the word is the use of or channeling of "life energies." Qigong can include meditation, breathing exercises, slow movement, and even religious practice.

Confucianism, Buddhism, and Taoism, the three basic strands of Chinese religious philosophy, offer variations of Qigong. For instance, Confucian ideology can emphasize the moral benefit of Qigong whereas Taoism inclines toward connection with the natural world. Purposes for practice of Qigong can be to promote longevity, to strengthen fighting techniques, to deepen meditative states, to work in conjunction with Chinese medicine, or to chant long sutras. Given the diversity of use, the Chinese government after the communist revolution has periodically attempted to standardize what Qigong stands for, to separate it from religious practice and to ensure the quality of institutions that use or study it. There is no distinct boundary between Qigong and Tai Chi, although the former tends to be associated with

breathwork and the later with distinct, meditative movement.

Western medicine has generally been dismissive of concrete health benefits of the practice, but with the growth of interest in Western society, that has started to change. There has been research that confirms the benefit for elders in balance and flexibility, cardiac health, and reduction of anxiety for PTSD. (See Further Resources for some recent research.)

After Joyce's experience with Mingtong Gu, she attended a few more weeklong workshops that focused on meditation and quieting the body. The workshops began early in the morning and went into the evening with periods of sitting in concentration. Sessions were long and arduous but satisfying, with lots of laughter and sharing during the breaks.

From there, Joyce continued a years-long exploration of how to move breath and energy in her body. When Joyce started, this practice was hardly recognized by Western medicine and still remains under-appreciated by allopathic medical practice. The Mingtong Gu work-shops strengthened what she had already discovered about moving in a way that forestalled acute pain. Patterns of movement are usually established in childhood and then become so automatic that they are unconscious: how to stand, how to sit, how to reach for something, how to sign your name. Sometimes, these patterns are inefficient.

The advantage Joyce found in retraining her body was either simplifying a movement or doing it in a different way that didn't trigger a nerve tweaked by a tendon. She discovered that other muscles or tendons can accomplish a task. With appropriate focus, she could make a less tiring gesture; this conserved her internal energy resources and left her with less fatigue and pain. Even later in life, Joyce goes on exploring ancient breathing techniques. In 2020, she reveled in a new book, *Breath: The New Science of a Lost Art*, by James Nestor, that explores a variety of breathing modes that can have a profound effect on health and energy.

In *Conversations with Trees*, by Stephanie Kaza, there is a de-

scription of walking through a forest using body wisdom rather than the mind. The author likens it to Tai Chi where the tactile connection to the ground becomes paramount. Rather than the head determining how to walk or the emotions of fear and uncertainty controlling where to place the foot, Kaza found she could "just let the ground support me." This mirrors Joyce's experience in letting go of her former habits and trusting that she could inhabit a strange new way of being in the world.

Joyce understood solitude in a new way and gained a deep appreciation for it. Writers such as Emerson and Montaigne extol solitude as a practice whereby the foundational self can be experienced. Emerson noted that it is easier to keep self-possession when physically isolated but that keeping the same equanimity in public requires a more intensive form of solitude. Likewise, Montaigne said that it is not enough to remove yourself from people but to remove the effects and habits of the population that is within ourselves. Joyce's stroke led to a gift of solitude. Stephen Batchelor explains in The Art of Solitude the internal expanse that opens when we can quiet all the noise that is not us.

A chance meeting at her condominium in 2002 led to further connection with Chinese traditions of movement. A neighbor she hardly knew urged her to take a Taoist Tai Chi Society class. Luckily, a branch held classes a couple of blocks away. As an instructor with the Society, she knew the health benefits of meditative movement. There were also special health-recovery classes that addressed all sorts of restrictions from joint replacements, MS, fused vertebrae and more. It was just what Joyce was open to.

There would be so much more.

CHAPTER 12
Tai Chi and Travel

The Taoist Tai Chi Society is an international organization founded by Taoist monk Moy Lin Shin in Toronto, Canada, in 1970. As a very young child in China, Moy Lin Shin was taken in by monks because a lung weakness had convinced his parents that he was bound to die. During his years in the monastery, he trained in movement arts, chanting, and Taoist ritual. Eventually he moved to Hong Kong as the Chinese Cultural Revolution was trying to wipe out all traditional forms of religion and culture. There he continued study with masters in his tradition. Finally, with encouragement from his elders, he moved to North America. He wanted to come to New York City, but immigration problems made it difficult, so he settled in Toronto.

Taoist Tai Chi combines movement practice with meditation, religious chanting and rites, social charity work, and banquets and celebration. Moy Lin Shin modified the traditional physical practice of Tai Chi in ways that would strengthen health benefits (rather than martial applications). He subtly included elements from related forms such as Lok Hup Ba Fa, Push Hands, and Bagua. Access to and use of the power called "Chi," or "Qi," is the basis of Tai Chi. Chi is a type of energy that runs through nature and through each individual. He believed that his mission was to help spread the healing benefits of Tai Chi as well as make it more widely available and understood in Western culture.

The society he founded started with a few members but quickly spread across Canada. Moy Lin Shin would even ask more accomplished students to move to new cities so that they could open new branches. He died in 1997, but the society lives on, now operating in more than twenty-five countries, from Poland to Australia and Scotland to Aruba.

The Portland branch began in 1987 with instructors coming from Vancouver, British Columbia, to help establish and train members. Early on it offered classes at the Hollywood Senior Center and Friendly House, expanding to numerous sites around the region. Since then, it has grown to be the largest branch in the US, with five hundred regularly paying members. (There are many thousands more who have participated intermittently over the years.) In 2011, it opened a beautiful space at the intersection of Sandy Boulevard and Glisan Street that includes a high shrine, a large practice area, and a full kitchen. Chinese New Year banquets for over 250 people that had been formerly catered can now be entirely prepared in the space. Twice a year it hosts a national or international workshop. (Due to the coronavirus pandemic at the time of this writing, the space is closed and group classes canceled. The local branch members remain in touch, practicing individually, while learning how to adapt to the current site challenges.)

Using a walker (that later became a cane), Joyce went to the studio for the beginner classes. After a brief introductory talk, the instructor demonstrated the first moves three times. Then he asked the students to join him. Almost immediately, Joyce crumpled to the floor. The instructor rushed over to her in obvious concern. Joyce shouted, "Get away from me. I can get up on my own. Don't help me." The instructor was baffled and backed away.

Joyce gathered herself and used what she had learned about her body to get up again. The class began again. Since the movements require shifting balance from one foot to the other, it wasn't long before she fell once more. Over the months that followed, Joyce would fall repeatedly, each time insisting that she could get up on her own.

The instructor, a longtime practitioner of Taoist Tai Chi, learned to overcome his instinctive response. He valued the determination he could see and related it to his own experience overcoming a broken back. It also served as a model of perseverance and bravery for other members. He let her be.

Early on, Joyce studied *Opening the Dragon Gate: The Making of a Modern Taoist Wizard* for all the similarities she found in her situation. Keeping a calm mind when desires pull at it clarifies the spirit. Emptiness arrived through practice centers the being. These were essentials in dealing with her condition. Lots of the meditative sitting she began in the Qigong workshop would later continue in the society's Tai Chi classes. Fostering the ability to sit quietly and guide her breathing through the body was one of the developments of individual growth that she was discovering. One teacher in the book guides the student to work with the forces that have formed an enormous, old pine tree; this was a lesson that struck a deep chord with Joyce. Imagining the tree to be a pillar of green energy allowed an exchange with the student that brought a deeper awareness of true nature. The book served as a compendium of purpose, focus, and practice from an esoteric and Taoist tradition.

Joyce became enamored with the society and began to actively take part in both the physical exercise and the organization. On one level, there was the simple physical challenge of learning the movements. Almost immediately she could sense how the coordination of movements, of upper body and lower body, and of energy flow throughout her system was beneficial. She liked the dedication of the instructors – all extensively trained volunteers because the society views teaching as a gift rather than a job. Other practitioners, both beginners and more experienced members, included those with similar movement challenges from stroke, MS, or Parkinson's as well as those without challenges. This created a community of learners and a society of friendly and engaged participants.

Tai Chi practice emphasizes internal awareness, balance be-

tween effort and relaxation, and consistency. Many of the movement patterns are based on nature: the names of moves such as Wave Hands Like Clouds or Parting Wild Horse's Mane speak of this connection. While there was respect for the individual, group coordination in the practice itself and in the organization was highly emphasized.

There were two benefits for Joyce. It made her less isolated in her struggle within her body, and it provided a framework for group activity the likes of which she hadn't experienced since the legislature. Joyce began to take part in the society's branch council that made decisions about local issues of scheduling, outreach classes, and intensive training workshops. She brought her political connections to the Chinese New Year banquets, donated dinners for fundraising events, joined discussion groups on Taoism, advised the supervisory council, and attended worldwide workshops with the top instructors who had once worked one-on-one with Moy Lin Shin. The society answered her everlasting curiosity about foreign cultures and added to the purpose, focus, and practice that could deepen the work on her energy flow in her body.

Each year, the society held a silent auction. One of the most desirable items was a dinner for eight at Joyce's loft in the Pearl District. Year after year, her hosting and cooking raised a fair amount of money for the nonprofit. As she had practiced in her legislative work, bringing others together was essential. Joyce always welcomed involvement to accomplish a shared purpose. A group, working together, can do more and can have fun doing it. Around the table with wine, a roasted pork loin, and the fixings, the guests bonded in friendship while adding to the support of the society.

Joyce's involvement with the society echoed much of her previous experience. There was openness to learning, physical focus, regular practice, a larger purpose that served the individual and the community, and a profound connection with the natural world. While she maintained her connection with the political world, the society offered her broader opportunities to contribute and explore. "I remember go-

ing to Tai Chi workshops around the world," she says. Although not an instructor herself, she built a name for herself in many international branches. It was enlivening but not always easy. She recalls, "Getting into people's cars was always a challenge. They did not understand how I needed to step up and then put my butt down to get in or throw myself to get out of the car." As always, that did not stop her.

She attended workshops in Edinburgh, Scotland, Balina, Ireland, and Helmond, Netherlands. The society has a hundred-acre farm in Orangeville, Ontario, that includes Taoist temples, a giant practice hall, a health-recovery center, and a columbarium where Moy Lin Shin's ashes are interred. She spent time there more than once. Because of her unusual determination and the effort through which she put her half-paralyzed body, she received attention of the most experienced and knowledgeable instructors. One senior member recommended special eyewear for when she practiced to counteract an imbalance in her seeing.

One memorable workshop was on the Caribbean island of Aruba. Aruba is a small island in the Antilles off the northern coast of South America. It had been controlled by the Netherlands for centuries, but in 1986 it seceded to become an independent country of the Kingdom of the Netherlands. Its economy had been tied to oil refining, especially for resources from nearby Venezuela, but it turned more and more to tourism. In 2019, the population was a little over 112,000, but it was well under 100,000 when Joyce visited in the first decade of the century.

The five-day workshop fell into a typical rhythm: classes from 10:00 a.m. until noon, lunch and rest period followed by afternoon sessions and then dinner and further instruction or discussion. At times, there were excursions. Joyce became curious about the number of prostitutes on the island. The government used Dutch soldiers to police the island and turn away illegal immigrants (often from Venezuela) or troublesome employees who had been hired to work for the state. The women (other Venezuelans) were there to sexually service

the soldiers. This echoed what Joyce had seen as a young woman in Cuba when she had observed how the effects of colonialism included sexual servitude. She continued to be disturbed by these distorted relations, though addressing them was beyond her current connections which were focused on Oregon issues or the work of the ACLU.

Travel continued to be a major component of her life. Her natural curiosity had first shown itself when she departed from South Dakota to travel across the country and eventually to Cuba. Later still she was willing to split her life between Oregon and Washington D. C. Later still she went to East Germany to see her son, Aaron, his East German wife, and her first grandchild. This trip took place before the Berlin Wall came down and involved a highly guarded train trip across the border. Now, Tai Chi expanded her world with new places and reasons to explore. Her physical disability increased the challenge of going around the world, but she refused to let it become an obstacle.

There were more adventures. She lived an active life. She stopped in local and national parks to hug trees – literally, not metaphorically. She took care of toddler grandchildren, teaching them how to help her change their own diapers because she was functionally only one-handed. As they aged, she traveled with them. All the while, she maintained her political and social connections to advise on health policy, on the environment, on land use, on power regulation, on the Oregon Trail museum, and on a hundred other things.

Friends she met in one of her early Qigong workshops invited her to the Big Island of Hawai'i. Once there, her friends introduced her to an area where swimmers could interact with dolphins. Naturally, Joyce was determined to get in the water. They rigged up a flotation device around her belly, and she practiced getting out of the boat with one arm and staying afloat. Each day the captain of the boat would figure out where the dolphins were and head there. Joyce would half climb, half fall out of the boat into the water. Then she would slowly paddle with one arm to the dolphins.

She experienced big mother dolphins bringing half a dozen

young ones to swim around her. "What was this strange being bobbing on the waves?" they seemed to be asking. Joyce could feel their energies and curiosity about her. Likewise, she felt connected to their active intelligences and to their aquatic environment. At the end of the day, she looked down to see a hundred dolphins sleeping on the bottom of the ocean and how "spooky" it was. Of course, then came the hardest part – paddling foot by foot toward the boat and climbing one-handed back into it.

Another journey was to Costa Rica. Costa Rica is well-known as the most stable and democratic nation in Central America. Having chosen to have no army, the country has prospered in many ways that other Central American countries long dominated by dictators have not. A country of about five million, it is known for its astounding ecological diversity. Almost a quarter of its area is environmentally protected jungle teeming spider monkeys, quetzal birds, and volcanic riches. It is a popular destination for ecotourists, with different zones offering surfing, wildlife exploration, river rafting, and mountain hiking. The Taoist Tai Chi Society had long maintained a branch near the capital of San José.

Joyce calls it "one of my more favorite places in the world because the country provided health care better than any place else." She noted how they trained young people to help in care without requiring them to first become a doctor or nurse. She practiced Tai Chi there and viewed some of the spectacular rainforest environments full of colorful birds, sloths, butterflies, and astounding frogs. She also bemoaned how rich Americans created gated communities to wall themselves off from the Costa Ricans: "They ruined whole places by these gates and walls." Sometimes these compounds would break up neighborhoods and separate families from the only nearby grocery. It was another example of the implicit colonialism she had first witnessed in Cuba, and like what she witnessed on Aruba, it was disturbing.

A discovery closer to home was how her personal energy manifested. In the US, Joyce remembers walking along with the cheetahs in

the National Zoo. She felt her energy and that of these predators spoke to each other. She was often aware of how strangers could react to her intensity even on the street.

She shares, "I used to go to New York City, and I remember walking with Maureen [her granddaughter] on the sidewalk with my cane. We were going out for the evening, and there were crowds of people coming at us." If you have experienced the bustle of a New York sidewalk, you understand that, like for drivers on the street, it's everyone for themselves. She continues, "People four feet away from us would just split and go around us because of my energy. One time a policeman came when we were crossing the street. He said, 'You know, lady, with your energy, you can stop cars.' I had learned from the Qigong master that this energy flowers in your belly opening onto the sides, and when you die, it flows out right here between your butt." How energy worked in her own body was one thing, but how it manifests between people was another. Her experience on the New York sidewalk heightened her awareness of the external and interpersonal exchange of energy with the natural world as well as with others.

An earlier example of this sense occurred in her loft. Traveling in the elevator to get her mail required all her learning: purpose to get the mail, focus to operate the elevator and not to fall, and practice day after day to master the operation. One day on this trip, she passed a young Black man she had never met or even seen before, yet she sensed an energy between them. She hadn't been thinking of anything other than accomplishing her task, but being open to the universe, she knew they needed to connect.

"We said hi and so forth, and then he said, 'Thank you.'" Joyce says she was momentarily puzzled. The man went on, "My mother's funeral was in Africa, and I was able to send the money you gave me to help pay for the funeral." It turned out that Joyce's generous New Year's tips, left for all building workers, not just the ones she had met, helped purchase the sugar that was part of his people's rite in burying her.

"The universe provides if you are open," Joyce believes. Making judgments, positive or negative, closes you off from that. Joyce explains, "If you are talking to somebody and you think, 'Oh, that person is saying a good thing,' it gets in the way of being open."

She learned to suspend her opinions and certainties even when talking with her children. Whether she liked or disliked what she heard, she discovered it made a movement in her body's energy field that interfered with connecting. The mind could get in the way of what was occurring. This insight is similar to one that is often expressed by spiritual leaders from the Dalai Lama to Nelson Mandela. Emotional reactivity clouds presence.

Another time, Joyce stepped out of the restroom at a Tai Chi class – and right in the path of a woman coming toward her who had immense negative energy. The energy was not directed at Joyce personally, but the cloud surrounding the woman was potent. "It actually made me fall down. Her negative energy was so strong that it just blew me over," Joyce says.

Following her precepts of purpose, focus, and practice came to include studying how to control her energy. If you let yourself get all riled up with all sorts of thoughts and feelings, it keeps you from connecting and being present to what is actually in front of you. You lose touch with your own being. You let forces around you control your decision-making and your actions. Joyce says it is one of the things that has kept her alive all this time in the face of tremendous obstacles. "It would be easy to just lay down and degenerate if I didn't have purpose, focus, and practice each day."

The greatest source of energy for Joyce is nature. From her childhood, she has felt a special affinity for flora and fauna. She often refers to pacing alongside the large predator cats in the Washington, DC, zoo, working with and riding the horses she grew up with, taking care of laboratory dogs, rabbits, and mice, and time she spent swimming with the dolphins. At her assisted-living home, she converses with the hummingbirds.

By far the most energy Joyce experiences is with trees. She is a literal and avid tree-hugger. She says she can feel their energy and the way it communicates with her internal energy. She would go to Tom McCall Waterfront Park, and for half an hour, she might have her arms around a tree. Concerned passers-by would stop to make sure she was okay. "Oh, yes," she assured them, "I'm just resting."

Her experiences echo what Stephanie Kaza discusses in *Conversations with Trees*. The author reflects on her own practices and relates about others who practice these types of interactions. She shares the story of Richard St. Barbe Baker, who was an early leader in reforestation and protection of trees. From the late 1920s through his death in 1982, he traveled the world establishing chapters of Men of the Trees (later renamed the International Tree Foundation). Baker promoted spending at least ten minutes a day holding a tree. He believed the tree's forces reenergized him. He preached that this practice was a natural cure for all sorts of physical and mental distress brought about by civilization and deforestation.

Joyce wholeheartedly agrees. She finds that trees share their energy with her and she with them. It is a language of touch, flow, and intuition. Clearing the mind and taking the time to settle, she clasps a tree to feel the surge of its power and growth. In addition to the energy conduits in her own body, there is the power the tree allows to rise from the earth and the breath it brings down from the sunlight and carbon dioxide. Not surprisingly, each tree is different.

Normally, we learn to divide the world into our inner subjective being and outer objective things. Among those objective things, we place other humans, sensate animals (usually mammals), and possibly a few other life-forms. We form other categories for cultural or social memes, for thoughts and feelings, and for information structures (that might include DNA, viruses, and codes). We can "think" a connection between these kingdoms and ourselves, but usually what that means is objectifying them so that we relate to them in the everyday way.

What Joyce learned, and what many others also experience

through meditation, was to overcome that divide to find communication. Instead of conceiving of things as separate (oneself and others), the experience of energy is one of connection. Therefore, hugging a tree, which can seem to be a silly self-indulgence, becomes a deeply meaningful embrace.

However, Joyce got a surprise when she visited the famous old-growth redwoods in Southern Oregon. With her granddaughter as a traveling companion, she was looking forward to the special communion so many find in these groves. Because of her other experiences, she was expecting a special sharing beyond usual awe because of the size and age of these giants. Joyce eagerly looked forward to the embrace and what she would feel. She reached out, placed her hands on the thick bark, and waited. She felt no energy. Whether it was their age, their lower vibration, or the thickness of their bark, she could not experience the same interaction she could with more common trees. Still, these ancient wonders inspired her.

CHAPTER 13
To Die or Not to Die

In 2017, Joyce was not feeling well. She was experiencing considerable pain from bone-on-bone deterioration in her hip and sleeplessness. She may have also had other ailments we can all get from time to time. A friend came from Seattle to help Julia with Joyce's care. As usual, Joyce had been resisting giving in to the medical establishment. During an all-night episode of excruciating pain, her friend remembers changing the bedsheets four times. Finally, she and Julia took Joyce to the emergency room.

During the care, a blood pressure cuff was left partially inflated on her good arm overnight. It caused more damage to her good arm and may have triggered a second minor stroke. After this incident, it was no longer possible for Joyce to live independently. Her mobility was curbed and her ability to provide basic care for herself diminished. Her functional arm was now compromised. Travel now would be impractical and even getting out locally to meetings or to the Tai Chi Society would depend on others.

Digesting this new constraint seemed unbearable and unfair. All her life, she had risen to meet obstacles. She had overcome the isolation of her upbringing, the impediments to women succeeding in the world of medical science, the opposition to uppity women in politics, and the physical handicaps brought on by her stroke. For more

than twenty years, she had forged an active life despite her disability and had relied on her own power. Now she was being set back again. It was too much.

This seemed like the end of her purpose, focus, and practice, except for one more action. The ongoing struggle to get around, to be involved, to observe, to participate, and to advise would be too much. She would have to give up her beautiful loft and be consigned to an assisted-living facility. It seemed the end of her road, and that prospect led to a new decision, but one that had long been contemplated. She would end her life.

"I'm not afraid to die," she says. Growing up on the farm and from her laboratory work, she had known enough about death to not be cowed by it. She could move to a home, but she didn't have to continue living. The standard of care for most patients in these circumstances is to prolong life at all costs. A course of medications that would cloud her mind was prescribed. Her family, in general, agreed with the doctors. Resignation, however, was not in Joyce's nature. If her life was to be so completely constrained, she would opt out. She decided that termination was her final choice. She repeatedly insisted that she was going to commit suicide.

Oregon was a pioneering "right to die" state. In fact, Joyce had been instrumental in helping to craft some of that legislation. In the law, there are a number of conditions that have to be met for physician-assisted suicide (PAS): a patient has to be in a terminal condition within the next six months, and a series of determinations must be made by licensed professionals that the person is legally qualified and competent to make such a decision – and this has to be determined more than once. Although Joyce could have easily met the competency requirements, her condition was not considered terminal. Therefore, she was ineligible to follow this course of action. Still, she was not fazed and felt that, if necessary, she could manage it on her own.

The ending of one's life intentionally is a topic fraught with memotion, religious considerations, social and family implications, and

legal concerns. It has a long history in human society but has generally been shunned in modern, Christian-based societies. Traditionally, the Roman Catholic Church has opposed it, considering it interfering with God's will. Likewise, Orthodox Judaism has also believed in only a natural ending to life, even in cases of extreme suffering. However, there have been changes, even in the Western world. A number of European countries and Canada have some form of assisted termination of life. In the US, as noted, Oregon has been a leader. Still, the specter of euthanasia generates tremendous resistance and is ethically complex for physicians, whose oath is "First, do no harm." The other path to suicide usually seems to be the violence of firearms, drug overdoses, or some form of asphyxiation. But another way is to stop eating and drinking, called Voluntary Stopping Eating and Drinking, abbreviated as VSED.

The difference between PAS and VSED is distinct. First, VSED is in a gray area legally and not specifically forbidden, whereas PAS must be legally sanctioned. While a physician may provide pain medication or help alleviate the dryness in the mouth for a person undergoing VSED, a doctor takes no active role in ending life. To many, this may seem more ethical. Also, with VSED, the dying person must have the will to maintain their decision over the course and could change their mind at any time. Unlike withi VSED, with PAS, as soon as lethal drugs are administered the decision is quick and irrevocable.

VSED normally takes about ten days to complete. The body slowly shuts down. Even the desire for food can diminish, as in fasting, and for long periods, thirst can abate as well. The patient begins to lose consciousness and lapses into a coma before the end.

Never one to be shy about what is going on, Joyce let it be known what she intended. She was tired of arguing with doctors and felt that if she had served her life purpose and was unable to continue, there was no point in hiding her resolve. Her family grew tired of her stubborn mantra and grudgingly – or sometimes with relief – accepted her decision. It was exhausting and difficult.

Over time, friends who understood the intricacies of the med-

ical system and also wielded some power stepped in for one more attempt to convince Joyce otherwise. Kitzhaber and others formed a care group that made clear that the medical establishment would have concrete directives for her ongoing care and assured Joyce that her needs would be met. Her wishes about medication would be respected. If she decided another time to follow the VSED path, her wishes would be honored, but at this moment, there was no need to act upon her choice. With their involvement, the immediacy of her need diminished. She settled into her assisted-living environment with the realization that she could continue because her wishes would be honored. She could continue consulting, practicing her Tai Chi exercises, reading, and interacting with nature.

One of her friends who visits her regularly met her through the Tai Chi Society. As for many before him, he hit it off immediately with Joyce's powerful personality. Before her second limiting stroke, he had participated in dinner parties at the loft and appreciated her contributions to a book group studying Taoism and Tai Chi. He admired Joyce staying involved in the group by phone when she could no longer attend in person.

There are many things he values in their relationship. It is a rare individual with whom one can talk and laugh with for hours, never slipping into negativity. Often their conversations revolve around nature. Sharing a story about a hike he took to a waterfall and how it made him feel would lead to Joyce remembering one of her experiences. The conversations often contributed to the well-being of both of them.

Joyce encouraged the artworks he was creating. Art, they agreed, had to make you feel something beautiful. She gently pushed him to be more productive and more confident in showing his work. As always with Joyce, there was support and positivity. They shared a reverence for creativity. He believes she has a singular ability to disseminate knowledge in a natural, non-pedantic way. As she does with everyone, she shares books, magazines, and ideas that open doors for

the listener. More than anything, he finds that Joyce consistently reminds him that you can be braver than you think, that you can go further and do more than you imagine. Her whole life serves as an example of overcoming adversity and being tough without being hard. It is a gift that has helped many.

Repeatedly, friends describe Joyce's spirit as indomitable. "One of a kind," "the strongest will of anyone I have ever met," "absolutely trustworthy," "in awe of [her] every day" are comments consistently spoken of Joyce. From her, they have learned not to give up no matter the obstacle – try again and find a new path. It may be pain, paralysis, political opposition, or sexism that confronted Joyce, but she was never deterred for long. Her children and grandchildren deeply admire and respect her legislative accomplishments, her remarkable strength, and even the double edge of her stubbornness.

She humorously spoke about her many "funerals." When she attended meetings with old-time friends and legislators, she would consider them potential funerals. It was fun to pretend that get-togethers were better than a real funeral – one that she could never attend. A light comes into Joyce's eyes when she says how good it is to have funerals before one dies.

As the externally active part of her life has wound down, reflection and evaluation of the unusual course of her life has become central. Friends have written eulogies for her to read. The Oregon State Capitol Foundation filmed an oral history interview with her for its archives. This book is another effort to pass on what she believes to be important lessons she has learned.

As her agency diminishes, Joyce continues to find purpose. Sometimes focus is difficult, and she regrets having to struggle for words. Nevertheless, her mind remains clear, and she continues to read and reflect. Kitzhaber still passes her documents for commentary – for example, a problem statement he was working on titled "Reframing the National Health Care Debate for 2020 Election Cycle." When, and if, she reaches a point where she can no longer participate in her life as

she wishes, she is certain she can use VSED to end her life on her own terms and with dignity.

Still, her curiosity is unabated. Stacks of books and magazines line her room. In each, there are yellow highlighted passages and notes scrawled in the margins. Stuffed in the books are lists of pages and concepts she has found intriguing. She often recommends books, podcasts, or the names of contacts to the steady stream of visitors who come to talk to or consult with her. Kitzhaber calls weekly and submits ideas and papers he has written for her commentary. Sometimes she even goes out to meetings around the state capital with old-time legislators. Naturally, she has formed a bond with the aides in her facility and experiences the flow of energies that she has realized in this part of her life.

Like the character in the medieval morality play *Everyman*, as she approaches the last phase of her life, Joyce has had to give up so much of what she loved: helping others through direct legislating, traveling and experiencing new environments. Yet Joyce does not despair. Self-pity is not an emotion she practices; if she remarks on some limitation, it is with a sprinkling of amusement: "I can still breathe, I can still go outside and do my Tai Chi exercises, I can still remember."

Her wonder and delight shine in her face. "Can you believe that little Joyce Cohen from South Dakota has gone through all these things?" she says. For a moment, she tears up at the thought of the decline she is going through. Still, she marvels. The sadness is mixed with joy. Even this is enough. Even still there is purpose, focus, practice.

PART III LESSONS

The latter part of Joyce's life brought some of her most important lessons yet:

Appreciate and use the abundance of nature.
Everywhere in the natural world are sources of wisdom and strength. From her childhood and all through her life, Joyce has interacted with and drawn sustenance from the world around her. Whether embracing a tree or chatting with hummingbirds, swimming with dolphins, or simply taking children down to a creek, she has interacted with the intelligence and life forces of nature.

Pay attention.
Whether it is subtle sensations in the body, the energy of others in conversation, or social and political conditions, take the time to notice them. It is too easy to slip into habitual ideas and feelings. Bring the mental world to clarity by focus and attention.

Overcome the divide between the objective and the subjective.
The main lesson Joyce learned from her accident and subsequent exploration of Qigong and Tai Chi was the interconnectedness of the inner world with the external. Becoming too subjective in focusing on your own feelings and ideas makes you lose contact with what is actually present; focusing on others and on the natural world simply as objects de-values them. Energy flows within the body and between beings.

Don't underestimate your bravery.
There are resources in each of us that can enable meeting the harshest setbacks. Speaking up when unpopular, helping when it is safer to retreat, choosing to meet your own disability and

weakness are always possible. You can always surprise yourself.

Don't give up.

All the old saws have value: where there is a will, there is a way; a journey of a thousand miles begins with one step; Rome wasn't built in a day. You may not know what to do; you may lack support of friends and family; you may be opposed by forces greater than your own. But there is a way to turn misfortune to fortune. As Joyce turned from outer success, she discovered new realms within her body, and when her body did not respond as it had formerly, she found ways to make it work.

EPILOGUE

In many ways, Joyce's life represents an antidote to the political and social climate in the twenty-first century. Her purpose was to reach out across boundaries to achieve a more caring and competent society while preserving the resources and environment that underly health. She fought against divisiveness by working across the political aisle, and she encouraged the young to strive for the greater good. In all of her political life, she fought for transparency, reason, access for all to health care, opportunity, and a clean and protected environment.

Joyce recognizes that the progressive policies she instituted continue to be opposed by corporate or narrow-minded conservative partisans. She still takes interest in current national and state issues and consults with former colleagues. She is distressed by the lack of civility and cooperation in the current political climate and wishes she could do more to answer it. The climate crisis is among her top concerns for her children and grandchildren. Of course, following her own advice, she would set a purpose to address the problem, spend the effort to understand the underlying causes, focus and discuss possible solutions, and practice all the means at her disposal to realize the change. Despair is not in her nature. There is always hope that she, and we, can make a better world.

Joyce has mentored many, from John Kitzhaber and Bill Bradbury to countless staffers and members of numerous organizations. As with many of the pioneering female legislators in Oregon, she has

guided, taught, and proven to be an example and an inspiration for those she has come in contact with. Her son values the independence he developed growing up with her and how she listened and her daughter finds the roots of her own strength in what she received from Joyce. Many of her colleagues admire her fearlessness and purposeful activity. Joyce is scrupulously honest, and if she changed her thinking, she was careful to let others understand why. One lobbyist comments how Joyce was a model not to copy but to aspire to. This woman especially admired how Joyce was able to redefine her purpose after the life-changing accident. She now reflects the lesson she learned from Joyce about how a person can take charge of their life no matter the circumstance. The admiration of her courage and capacity is well deserved.

With her own clear purpose in mind – to inspire, encourage, and support others – Joyce puts forth the importance of purpose, focus, and practice as both a theoretical method and a practical means of achieving an effective, worthwhile life. It is up to each of us to take her wisdom and create a future for our children and grandchildren, making our life as vital and generous as hers has been.

Joyce Cohen

ACKNOWLEDGMENTS

I have deep appreciation for all those who contributed time and insight through conversation. Thank you to the members of Joyce's family: Scout Cohen-Pope, Sullivan Cohen-Pope, Aaron Cohen, and Julia Cohen, who shared stories and details of her life.

Thank you to the colleagues and aides in the Oregon legislature who illuminated her working life, including Bill Bradbury, Nan Heim, John Kitzhaber, Fred Neal, and Kathryn Nichols.

Bruce Bishop, Fred Hansen, and Gail Yazzolino also contributed background information. Without Jane Cease's early and thorough support, this journey would not have been successful. Margot Dick's long friendship with Joyce clarified much about her recovery.

Practice and connection through the Taoist Tai Chi Society indirectly generated this book; Peri Dolgins and Allen Pearce helped fill in Joyce's early experience of Taoist Tai Chi.

I would not have been able to complete this book without the invaluable editing and advice of Rebecca Pillsbury at Duende Press and the work of her team, including Bryan Tomasovich, Kristin Thiel, and Antonio García Martín. Any errors that remain within the book are entirely mine.

WHO'S WHO

Vic Atiyeh: Thirty-second governor of Oregon (1979–87) and political mentor for Joyce

Fulgencio Batista (1901–73): Dictator of Cuba who ruled prior to and during prior to and during the Castro revolution; fled to Dominican Republic and then Portugal after being overthrown

Gert Boyle (1924–2019): Portland businesswoman and longtime president of Columbia Sportswear; philanthropist

Bill Bradbury (b. 1949): Member of the Oregon House and Senate for fourteen years (1981–95); Oregon Secretary of State (1999–2009); implemented Oregon's vote-by-mail system; a close colleague of Joyce's

Tabitha Moffatt Brown (1780–1858): Pioneer and "Mother of Oregon"

Jane Cease (b. 1936): Member of the Oregon House (1979–85) and Senate (1985–91); close friend and colleague of Joyce's

Aaron Cohen (b. 1963): Joyce's son

Julia Cohen (b. 1966): Joyce's daughter

Scout Cohen-Pope (b. 1994) and Sullivan Cohen-Pope (b. 1997): Two of Joyce's grandchildren

Stanley Cohen (d. 1995): Social activist and organizer; Joyce's husband (1960–1984)

Abigail Scott Duniway (1834–1915): Staunch suffragist and promoter of women's rights

Ralph Waldo Emerson (1803–82): Renowned essayist, philosopher, and poet

Viktor Frankl (1905–97): Psychiatrist, philosopher, and concentration camp survivor; author of Man's Search for Meaning

Neil Goldschmidt (b. 1940): Mayor of Portland (1972); US Secretary of Transportation (1979–81); thirty-third governor of Oregon (1986–90)

Doris Kearns Goodwin (b. 1943): Biographer and historian; author of Team of Rivals and Leadership in Turbulent Times

Edith Green (1910–87): US congresswoman from Oregon (1955–74)

Fred Hansen (b. 1946): Director of the Oregon Department of Environmental Quality; Deputy Administrator of the Environmental Protection Agency (1994–98); head of TriMet, Portland's regional public transportation authority; Joyce's husband (1984–2004)

Darlene Hooley (b. 1936): Member of the Oregon legislature (1981–87); US Representative 1997-2008; colleague of Joyce

Vera Katz (1933-2017): Member of the Oregon Legislature (1973-90); elected first female Speaker of the House (1985); three-time Mayor of Portland (1993-2004); colleague of Joyce

John Kitzhaber (b. 1947): Oregon legislator 1978-93; president of the Senate (1985–93); thirty-fifth and thirty-seventh governor of Oregon (1995–2003, 2011–15), longest-serving Oregon governor; close friend and colleague of Joyce's

Ursula K. Le Guin (1929–2018): Prominent and award-winning writer and pioneer in science-fiction

C. Walton Lillihei (1918–99): Pioneer in open-heart surgery; Joyce participated as a medical tech in some of his path-finding work

Roger Martin (b. 1935): Oregon legislator (1967–78); defeated Joyce in her first race for the Oregon House; lifelong friend of Joyce's

Moy Lin Shin (1931–98): Taoist Monk; founder of the Taoist Tai Chi Society and a Canadian branch of the Fung Loy Kok Institute of Taoism

Hardy Myers (1939–2016): Oregon legislator (1967–78), Speaker of the House (1980–84); Attorney General of Oregon (1997–2007); colleague of Joyce's

Eric L. Nelson (1924–2016): Researcher, coauthor of paper on DNA with Joyce; early vice president of pharmaceutical company Allergan

Maurine Brown Neuberger (1907–2000): US Senator from Oregon (1960–67) Kathryn Nichols: A legislative analyst who worked for Joyce

William H. Parker III (1905–66): Los Angeles police chief (1950–66); modernized, militarized, and popularized tough policing; oversaw a racist department including during the 1965 Watts Riots

Norma Paulus (1933–2019): Member of the Oregon House (1970–75); first woman elected to statewide office, as secretary of state (1977–85)

Joseph Petik (1906–65): Joyce's father

Vaclav Petik (1876–1956): Joyce's grandfather

Barbara Roberts (b. 1936): Oregon House member (1981–84); Oregon Secretary of State (1984); first female Oregon governor (1991–94); colleague of Joyce's

Betty Roberts (1923–2011): Oregon House member (1964–68); Oregon Senate member, the only woman at the time (1968–76); first woman appointed to Oregon Court of Appeals (1977); Oregon Supreme Court justice (1982–86).

Evelyn Sampson (1910–2004): Joyce's mother

Solon (c. 630–c. 560 BCE): Athenian landowner and lawmaker who instituted major reforms

Richard St. Barbe Baker (1889–1982): Environmental activist and author committed to reforestation; founder of the International Tree Foundation

Bob Tiernan: Politician who lost two Oregon Senate races to Joyce

William U'Ren (1859–1949): Progressive Oregon legislator

who championed the Oregon Plan and direct election of US senators

Sarah Winnemuca (1844–91): Northern Paiute author, activist, and educator

William Butler Yeats (1865–1939): Irish poet, playwright, and Nobel Prize winner.

FURTHER RESOURCES

Tai Chi Research

www.taoisttaichi.org: This is the general site of the Taoist Tai Chi Society and contains a wealth of information about the practice and research on its health benefits. See, for example:

"The Health Benefits of Tai Chi," Harvard Health Publishing, Harvard Medical School, updated August 20, 2019, www.health.harvard.edu/staying-healthy/the-health-benefits-of-tai-chi.

Jane Brody, "Using Tai Chi to Build Strength," *New York Times*, September 10, 2018, www.nytimes.com/2018/09/10/well/move/using-tai-chi-to-build-strength.html.

Patricia Huston and Bruce McFarlane, "Health Benefits of Tai Chi: What Is the Evidence?" *Canadian Family Physician* 62, no. 11 (November 2016): 881–90.

Roger Jahne et al., "A Comprehensive Review of Health Benefits of Qigong and Tai Chi," *The American Journal of Health Promotion* 24, no. 6 (July–August 2010): 1–25.

Sang Hwan Kim et al., "Mind-Body practices for Posttraumatic Stress Disorder," *Journal of Investigative Medicine* 61, no. 5 (June 2013): 827–34, www.doi.org/10.2310/jim.0b013e3182906862.

David Marshall et al., "Evaluation of a Tai Chi Intervention to Promote Well-Being in Healthcare Staff: A Pilot Study," *Religions* 9 no. 2, www. doi.org/10.3390/rel9020035.

Pao-Feng Tsai et al., "Tai chi for Posttraumatic Stress Disorder and Chronic Muscoskeletal Pain: A Pilot Study," *Journal of Holistic Nursing* 36 no. 2 (June 2018): 147–58, www.doi.org/10.1177/0898010117697617.

Chenchen Wang et al., "Tai Chi on Psychological Well-Being: Systematic Review and Meta-Analysis," BMC *Complementary Alternative Medicine* 10, no. 23, www.doi.org/10.1186/1472-6882-10-23.

Fang Wang et al., "The Effects of Tai Chi on Depression, Anxiety, and Psychological Well-Being, a Systematic Review and Meta-Analysis," *International Journal of Behavioral Medicine* 21, no. 4 (August 2014): 605–17, www.doi.org/10.1007/s12529-013-9351-9.

Mingtong Gu, www.artoflivingretreatcenters.org

Sites supporting women in Oregon Politics

Center for Women's Leadership at Portland State University, www.pdx.edu/womens-leadership, 503-725-2895, cwlinfo@pdx.edu

Emerge Oregon, or.emergeamerica.org, PO Box 3493, Portland, Oregon 97208, 503-729-7039, contact@emergeor.org

Emily's List, emilyslist.org, a national political action committee dedicated to supporting Democratic women running for office.

WINPAC (Women's Investment Network Political Action Committee), oregonwinpac.com. The founding "mothers" of WINPAC are Betty Roberts (former legislator and first women to serve on the Oregon Supreme Court); Jewel Lansing (former auditor for Portland and Multnomah County); Gretchen Kafoury (former legislator, city and county commissioner); Darlene Hooley (former county commissioner, legislator, and congresswoman); Maureen Leonard (then Oregon Supreme Court clerk); and Patricia McCaig (then assistant to Oregon Secretary of State Barbara Roberts).

Women's Center for Leadership, womenscenterforleadership.org, PO Box 25756, Portland, OR 97298, womenscenterforleadership@gmail.com.

Jewel Beck Lansing, *Campaigning for Office: A Woman Runs* (Saratoga, CA: R & E Publishing, 1991).

James Andrew Long, *Marching Forward: Northwest Women's Firsts: 1,444 Role Models* (North Plains, OR: Pumpkin Ridge Productions, 2001).

BIBLIOGRAPHY

A Path of Dual Cultivation: Teachings of the Fung Loy Kok Institute of Taoism. Toronto: Fung Loy Kok Institute of Taoism, 2008.

Batchelor, Stephen. *The Art of Solitude.* New Haven, CT: Yale University Press, 2020.

Carlson, Susanne. *Who Do I Become When I am No Longer Me?* Self-published, Inkwater Press, 2012.

Detzer, David. *The Brink: Cuban Missile Crisis, 1962.* New York: Thomas Y. Crowell Company, 1970.

Duniway, Abigail Scott. *Path Breaking.* New York: Schocken Books, 1971.

Edwards, Cecil L., comp., *Alphabetical List of Oregon's Legislators.* Salem, OR: State of Oregon Legislative Administration Committee, 1993.

Emerson, Ralph Waldo. *Self-Reliance and Other Essays.* New York: Dover, 1993.

Frankl, Viktor E., *Man's Search for Meaning.* Boston: Beacon Press, 2006.

Gordly, Avel Louise, with Patricia A. Schechter, *Remembering the Power of Words: The Life of an Oregon Activist, Legislator, and Community Leader.* Corvallis: Oregon State University Press, 2011.

Heider, Douglas, and David Dietz, *Legislative Perspectives, A 150 Year History of the Oregon Legislatures from 1843 to 1993.* Portland: Oregon Historical Society Press, 1995.

Jahren, Hope. **Lab Girl.** New York: Alfred A. Knopf, 2016.

Kaiguo, Chen, and Zheng Shunchao, *Opening the Dragon Gate: The Making of a Modern Taoist Wizard.* Translated by Thomas Cleary. Boston: Tuttle Publishing, 1998.

Kaza, Stephanie. *Conversations with Trees: An Intimate Ecology.* Boulder: Shambhala Publications, 2019.

Landau, Judith. *A Different Ending.* Self-published, CreateSpace, 2017.

Lansing, Jewel. *Portland: People, Politics, and Power.* Corvallis: Oregon State University Press, 2003.

Levy, Jeffrey. *Until One Faces North.* Self-published, Lulu.com, 2019.

Long, James Andrew. *Oregon Firsts, Past and Present.* North Plains, OR: Pumpkin Ridge Productions, 1994.

Maben, *Manly. Vanport.* Portland: Oregon Historical Society Press, 1987.

Nestor, James. *Breath: The New Science of a Lost Art.* New York: Riverhead Books, 2020.

Neuberger, Richard L. *Adventures in Politics: We Go to the Legislature.* New York: Oxford University Press, 1954.

Paulus, Norma. *The Only Woman in the Room, the Norma Paulus Story.* Corvallis: Oregon State University Press, 2017.

Roberts, Barbara. *Up the Capitol Steps: A Woman's March to the Governorship.* Corvallis: Oregon State University Press, 2011.

Roberts, Betty. *With Grit and by Grace: Breaking Tails in Politics and Law–A Memoir.* Corvallis: Oregon State University Press, 2008.

Schlesinger, Arthur. *The Dynamics of World Power: A Documentary History of the United States Foreign Policy 1945-1973.* McGraw Hill, 1973.

Screech, M. A., ed. and trans. *Michel de Montaigne, the Complete Essays.* London: Penguin, 1991.

Walker, Matthew. *Why We Sleep.* New York: Simon & Schuster, 2017.